draw
yourself
happy

To my darling wife, Eunice, without whom I could not have written this book.

An Hachette UK Company
www.hachette.co.uk

First published in Great Britain in 2017
by ILEX, a division of
Octopus Publishing Group Ltd
Carmelite House
50 Victoria Embankment
London EC4Y 0DZ
www.octopusbooks.co.uk

Copyright © Octopus Publishing Group Ltd 2017
Text and illustrations copyright © Alex Beeching 2017

Distributed in the US by
Hachette Book Group
1290 Avenue of the Americas
4th and 5th Floors
New York, NY 10020

Distributed in Canada by
Canadian Manda Group
664 Annette St.
Toronto, Ontario, Canada M6S 2C8

Publisher: Roly Allen
Editorial Director: Zara Larcombe
Editor: Francesca Leung
Managing Specialist Editor: Frank Gallaugher
Editor: Rachel Silverlight
Admin Assistant: Sarah Vaughan
Art Director: Julie Weir
Designer: Louise Evans
Assistant Production Manager: Lucy Carter
Production Controller: Sarah Kulasek-Boyd

Alex Beeching asserts the moral right to be
identified as the author of this work.

ISBN 978-1-78157-414-0

A CIP catalogue record for this book is available
from the British Library.

Printed and bound in China

10 9 8 7 6 5 4 3 2 1

ALEX BEECHING

draw yourself happy

ilex

contents

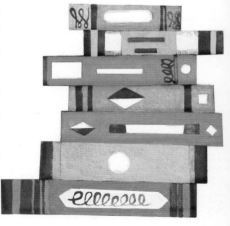

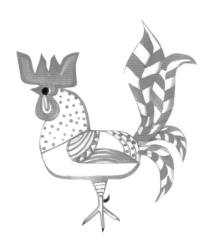

introduction

This book is devoted to one purpose and one purpose only: to "draw yourself happy." Three simple words, but behind them lies a great deal of meaning. If you enter into the spirit of the book, let go of your preconceptions, and leave ego at the door, I guarantee that it will help. Much like a smorgasbord, there should, I hope, be something for all tastes and abilities.

WHY DRAWING?

It is much to be regretted that the last time most people drew was at school. Indeed, it may be the last time they thought creatively at all. This is a great pity, because drawing and creativity go hand in hand. Seeking out new ways of looking at the world, turning things on their head, connecting the hitherto unconnected, and thinking the impossible should be pursued, not only to solve problems at work, but to keep the mind nimble.

Of all the qualities you should cultivate, to my mind, the most important is this: a sense of wonder. Try and approach the world as if for the first time, much as a child does. Doing so can turn a world that is black and white into one of color and fun at a stroke.

But to bring about this sense of childlike wonder, there is much that you must unlearn in the way of bad habits. How many of us go about our business as if asleep? You know the type: stooped over their phone, cut off from the world, and often none too happy. Drawing can build a bridge back to a world of poetry, sunshine, and laughter.

My method is simple: what's fun? What isn't? What brings a smile to your face? And so I have devised exercises in which you can dance the flamenco in Spain, have a café au lait in Paris, raid the candy jar, mix your own cocktail, bust a bird out of jail, create your own coat of arms, and much, much more.

HOW TO USE THIS BOOK

So, this book isn't really a book at all. It's a toy box, a tool box, and a box of delights all rolled into one. You don't have to do the exercises in order—dip in and out or make up your own rules—but all the while keep this question uppermost in your mind: what makes you happy?

Invest in some good art pens, or improvise with what you've got—it's entirely up to you. Whether it's an old pencil you have in a drawer or a felt-tip pen by the phone—it can bring a spark of light to the darkness. When you start an exercise, forget about actively pursuing happiness. Just concentrate on the process, not product nor purpose. If you go wrong, don't worry, it doesn't matter. Trust me, I'm an illustrator!

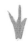

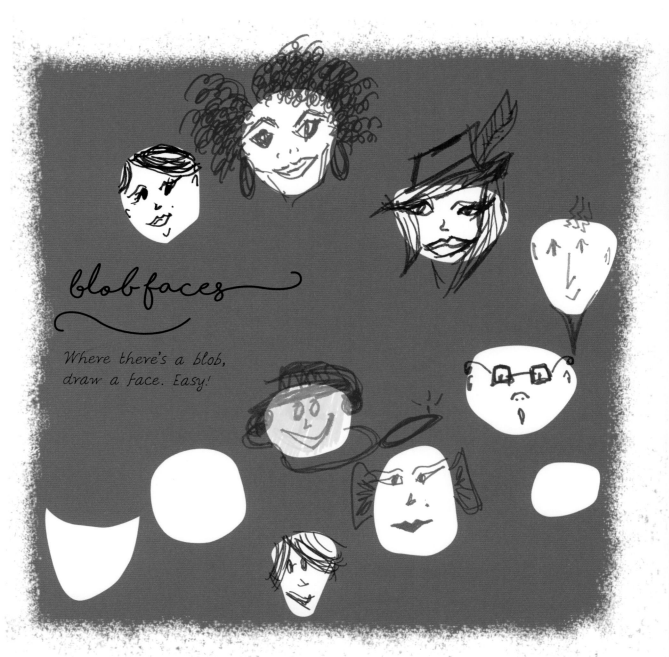

blobfaces

Where there's a blob,
draw a face. Easy!

fingerprints

fingerprints

fingerprints

Fingerprints make an excellent starting point for all manner of pictures. I used an ink pad but you could use paint instead.

When the fingerprints are dry, why not turn them into things like faces, flowers, or balloons by adding pen?

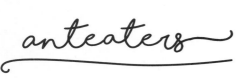

anteaters

Predictably enough, ants, ants, and more ants are on the menu for anteaters.

Add as many more ants to the page as you would like, with some leaves and flowers too.

Next, it's the turn of the anteaters with their very long tongues. Continue the lines of the tongues drawn here to loop this way and that, and see how many unfortunate ants you can draw your lines through in one swoop.

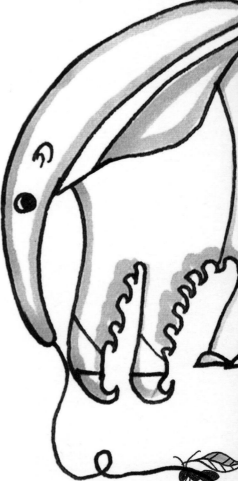

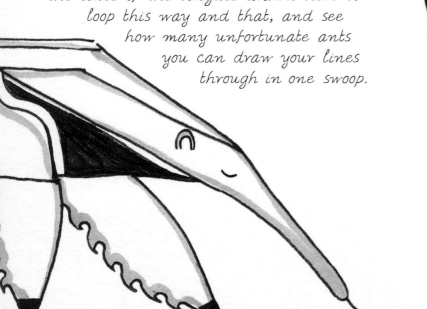

shoe collection

Here's your chance to create
your dream shoe collection.
I've given you some templates
of shoes, as seen from above,
to start you off.

parakeets

Parakeets are some of the most beautiful birds around. Add your own color to these however you want, with a suitably vibrant background too.

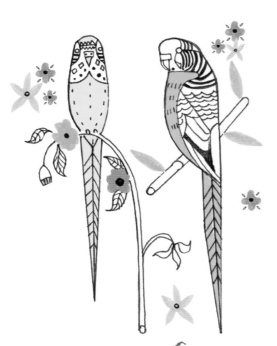

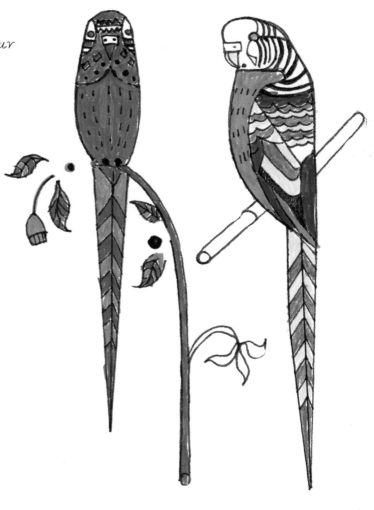

bubbles

Envelop this elegant woman in a cloud of bubbles
by drawing them all around her.

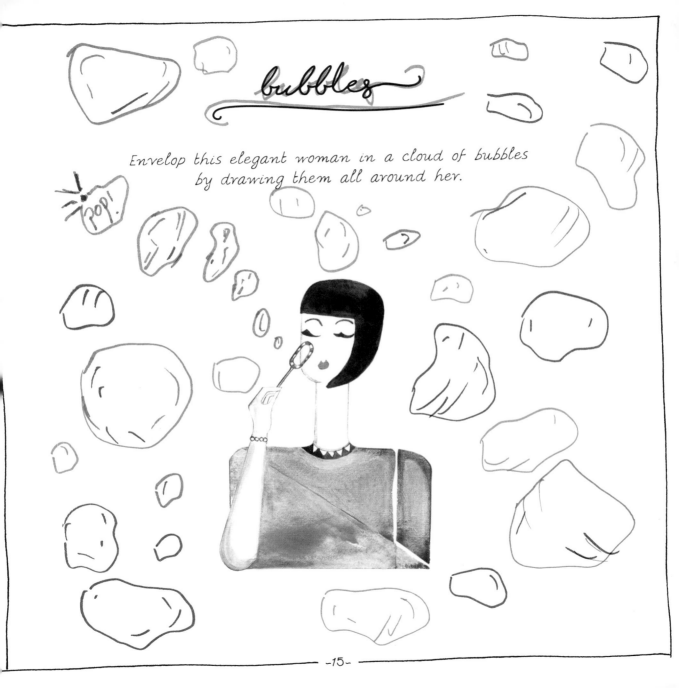

build a village

You might have heard of the video game "Civilization." The idea behind it is to carve out an empire to stand the test of time. Instead of founding an empire by the sword, here you're going to build a village, complete with trees, a church, and other buildings.

Work from front to back to give a sense of depth and don't be afraid to make the buildings crooked. It adds character!

bus

The bus is missing a few passengers. Your mission, should you choose to accept it, is to draw this woman looking at her phone. If, after drawing her, you feel like adding some more passengers, then go ahead.

As you can see, we can do much with little. A few lines can go a long way in a drawing.

 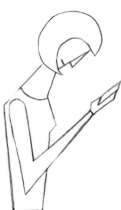 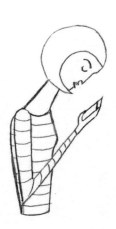 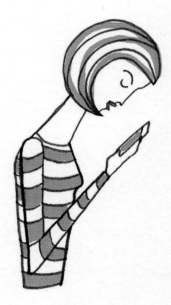

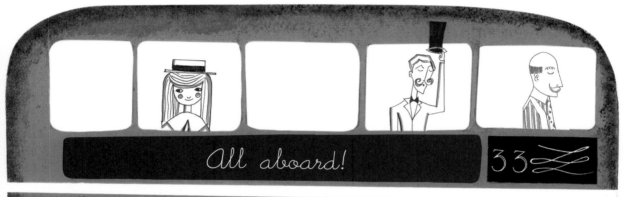
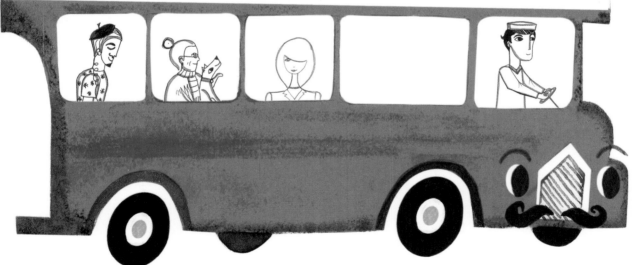

bust the bird out of jail

These birds are making a break for freedom!
Draw as many more as you like that have
also escaped from the cage.

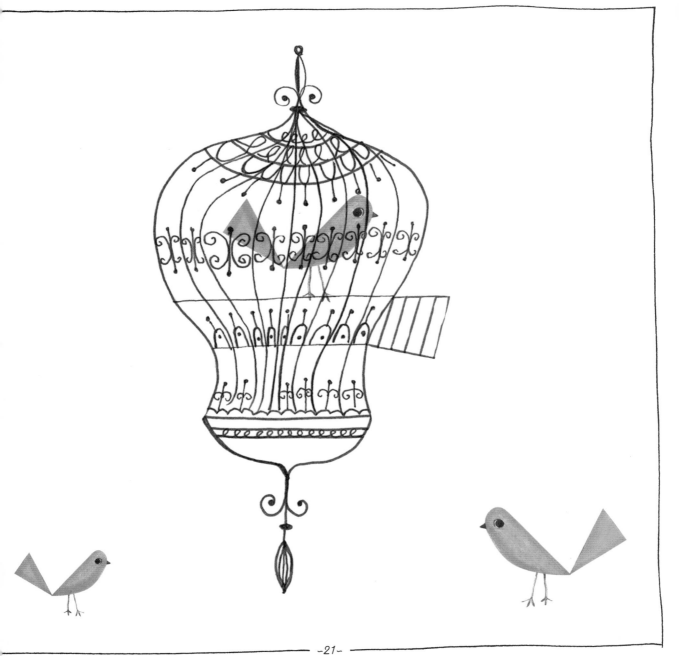

butterfly net

Draw as many butterflies as you want on this page and then add the butterfly net to catch them!

flora

Flora was the Roman goddess of spring and flowers. Add your own blooms to the field here, with splashes of color in paint, art pen, pencil, crayon, or felt-tip on the page.

You don't need to be too precise—a certain looseness of approach works better to give a natural sense of movement.

checkmate!

Checkmate is a corruption of the Farsi for "Shakh Mat" which means, "the king is dead."

 The King can only move one square at a time in any direction.

 A formidable piece, the Queen can move in any direction for any number of squares. Originally known as the "Counselor," its present form dates back to the 15th century.

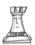 The Rook or Castle can move in any direction vertically or horizontally and used to be represented by a chariot.

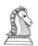 The Knight is the only piece that can leap over other pieces. It can move one square horizontally and two vertically or vice versa.

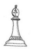 The Bishop can move any number of squares diagonally. To the Hindus and Arabs, it was known as the "Elephant."

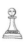 The Pawn can only move forward one square at a time, but can move forward two squares on its first move. In German, it is called the "Peasant."

Pick your favorite piece and draw it. Or, if you're feeling ambitious, maybe attempt a whole set. You can add shading for black pieces.

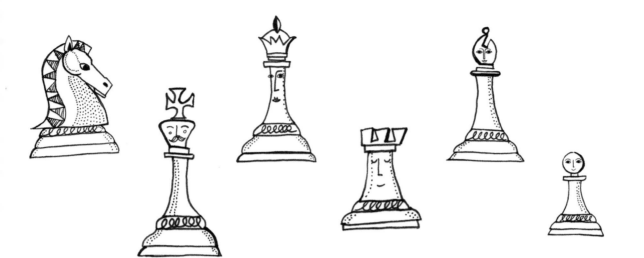

glass bottles

gather as many different colors of pencil, pen . . .
whatever you can find to draw with. What shapes and
sizes of apothecary bottles can you add to this collection?
Try overlapping smaller bottles in front and larger bottles
at the back to give a sense of numbers and depth.

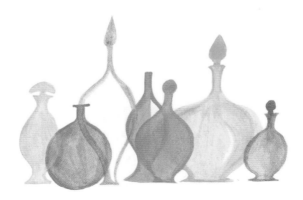

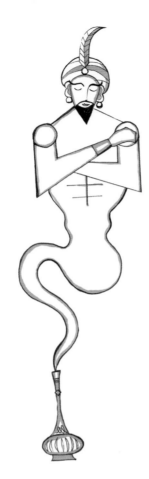

genie

While my genie is straight from central casting, yours could take any number of forms. For instance, it could take a female form, it could be mere smoke or some other entity entirely. Don't forget to draw the bottle, lamp, teapot, or whatever else it's emerging from.

how to paint a christmas tree

*Imagine you are Zorro (a.k.a. Don Diego de la Vega),
he of the mustache, domino mask, and black sombrero, buckling
his swash and lunging gracefully with a rapier.*

*Instead of leaving his trademark "Z"; I want you to cut
ten horizontal strokes with a paintbrush or brush pen. Summon
the same devil-may-care attitude for the trunk and pot in
which the tree sits.*

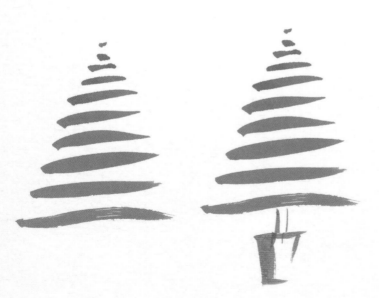

Now paint a forest of trees (without pots) on this page. If you overlap them and make them smaller at the back, this will help to add a sense of distance and perspective. You could add some snow, people, or forest animals too, if you want, to complete the scene.

cinderella's carriage

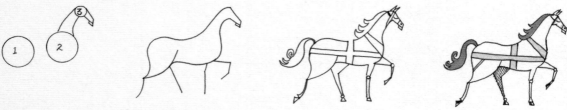
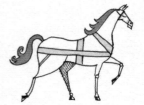

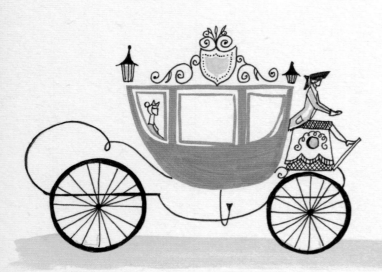

circus horse

Horses are supposed to be notoriously difficult to draw. To that, I say nonsense! This exercise proves it—try it yourself with this gorgeous example.

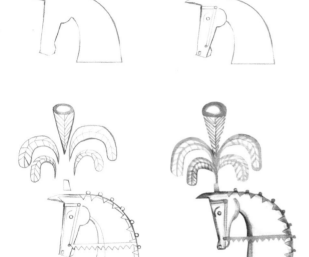

clouds over the golden mountain

This fantastical scene could do with some atmosphere. Here's how to add some clouds floating overhead.

1. Draw a horizontal line like so:

2. Starting at the left, throw out a series of curves above the line. The last of the curves should taper until it meets the point at the other end on the right.

3. For the bottom of the cloud, repeat the process, only in reverse.

4. Shade the top and bottom, preferably in contrasting tones, and it's done. You could also add a few more in various sizes and colors, or try some different shapes of your own.

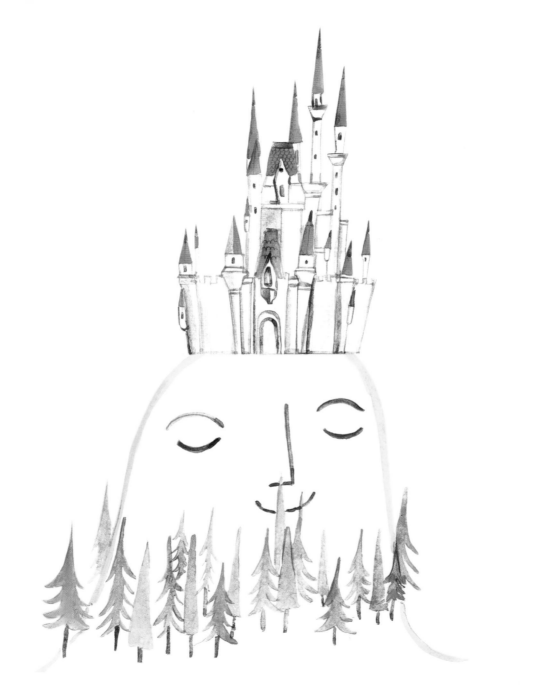

rooster

Find some pictures of roosters, either online or in a book. Pick one and spend a little time thinking about how you might go about simplifying it geometrically by following a few rules.

For example, for my rooster, I decided to simplify the body shape and decorate it with stripes, circles, and triangles. Other rules you might want to try are using only straight lines or only curved lines, or decorating only with dots or stripes.

Once you've had a think, start sketching. If you can see part of the rooster that could be a square, then make that a square in your drawing. If you can see a circle, draw a circle. If there is something that is nearly a straight line, draw it as a straight line, and so on.

Keep the rules you decided on at the beginning in mind until you have drawn something you're happy with. Then it's a question of tinkering with it, refining it, and making your drawing sing.

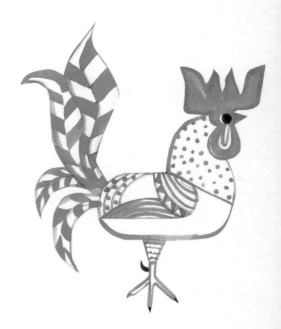

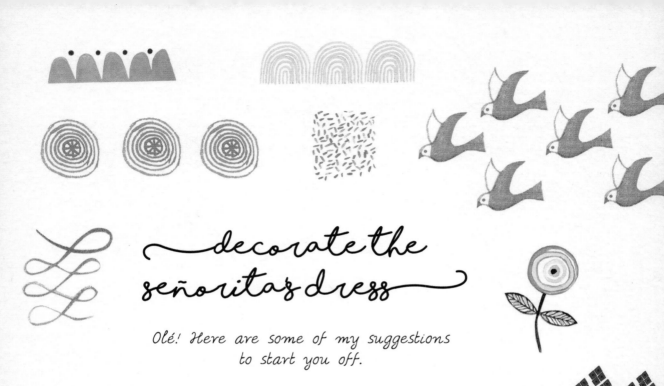

decorate the señoritas dress

Olé! Here are some of my suggestions to start you off.

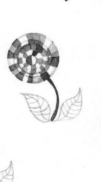

y si me cortan el peso
y si me muerden serpientes

me esconderé en
mis castillos
y esperaré a que
despiertes
y si te fueron
las cosas
yo sólo soy un
borracho y aquí
tú eres la bruja
y yo soy el

embrujado.

pour yourself a cocktail

Welcome to the "Draw Yourself Happy" Bar. It's like any other bar, only better because there are no hangovers!

Mix your own tipple by drawing it. Be wonky, be wild, and be bold. And the only limit to how many drinks you can have is how many you draw.

You can really personalize your bar by drawing shelves of your favorite drinks as well as any other decor in the background.

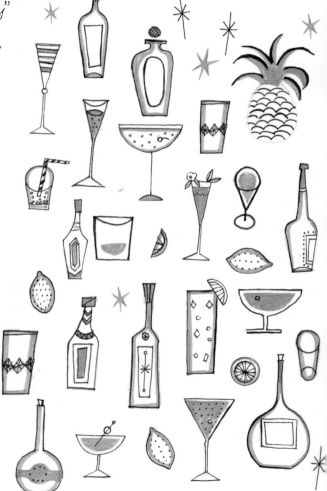

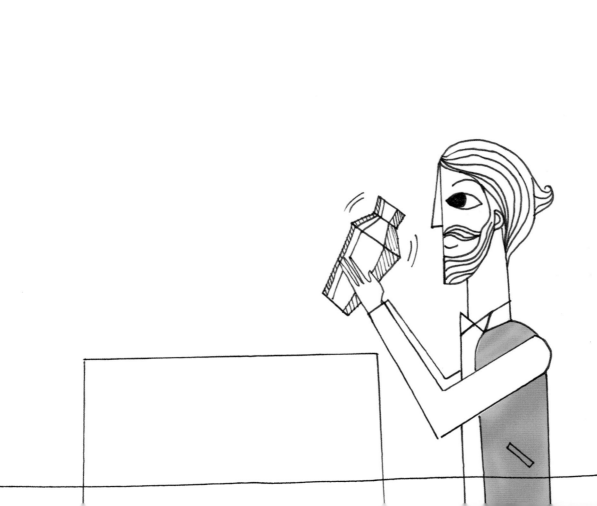

cuckoo clock

Add the numbers missing from the clockface opposite.

I used Roman numerals in two contrasting colors
here but you can choose whatever you like—
Roman numerals, Arabic numbers, Chinese characters,
or anything else you can think of.

Here's some space below to experiment with your number
designs before you add them to the clockface.

I II III IV V

VI VII VIII

IX X XI XII

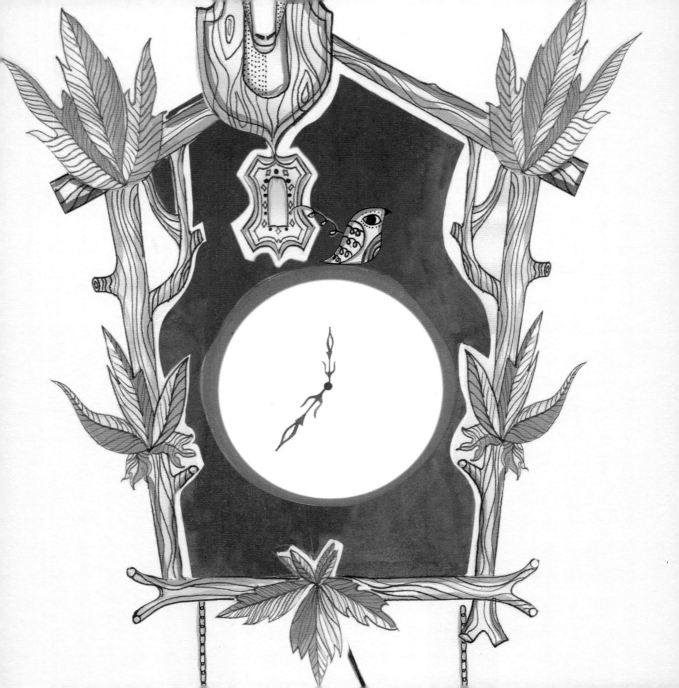

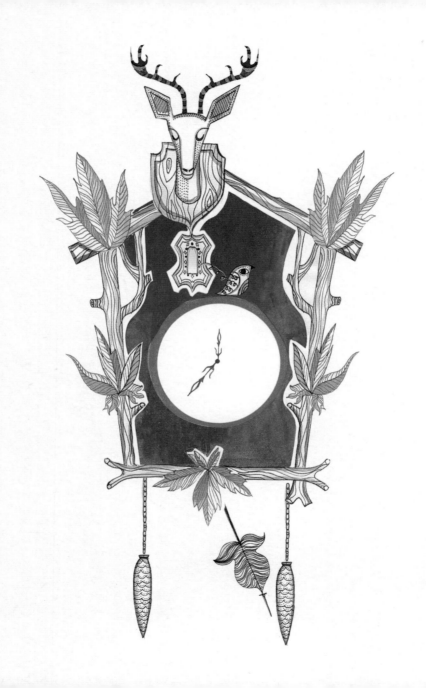

Now try designing your own clock
on this page. What kind of features
do you want to include? A pendulum?
Does it chime or have something pop
out on the hour? Does it hang on
the wall or is it self-standing?

beat the blues

Does this exercise strike you as silly? Good. Because it's meant to be—this croc eats the blues.

What does melancholy look like to you? Perhaps a dark, tangled cloud might serve as a starting point.

First, draw a rough cloud shape in pencil. Then scribble within the shape in pen or felt-tip pen and, finally, erase your pencil guidelines.

Keep drawing these clouds until the blahs abate.

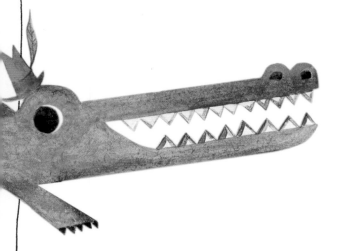

salt
AND
pepper

Anything inanimate can be brought to life, like the salt and pepper shakers here. Try drawing your own in whatever shapes and sizes you like, and giving them a bit of personality by adding faces.

Pepper, sir? Madam? If the answer is yes, add some sprinkles of pepper too. Dots, dashes, triangles. How do you visualize it?

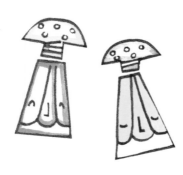

decorate the matchbox

Create your own customized design on this matchbox.

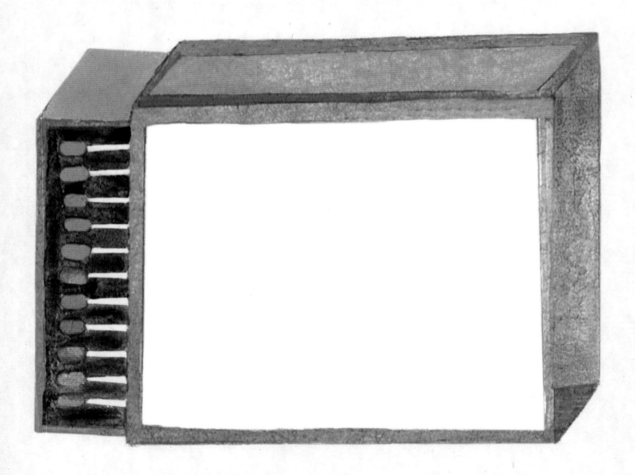

desert island

Desert islands have long been a source of fascination—the most famous one is probably in Daniel Defoe's "Robinson Crusoe."

Try drawing your own island. Here's some inspiration for you. What does your island have on it? How big is it? Is there any hope of rescue?

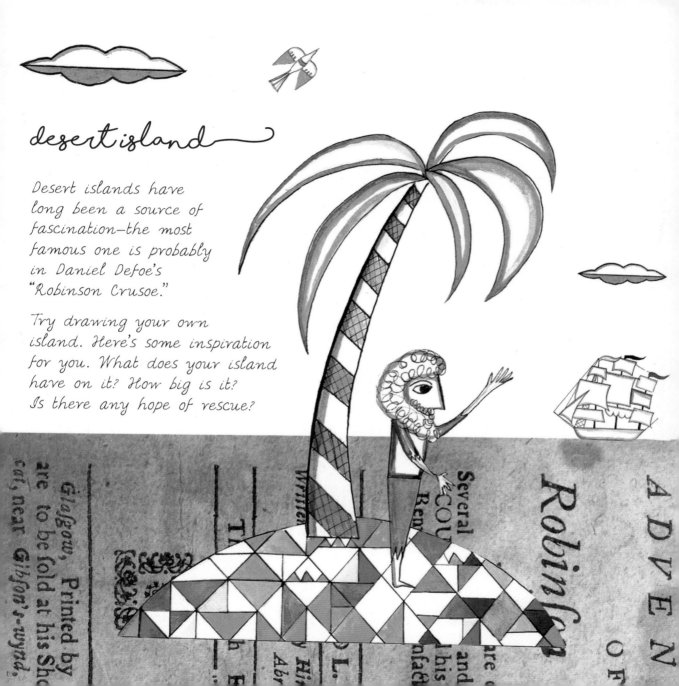

frogs

It's raining frogs! Here's a quick exercise
to show you how to draw one. Draw as many
as you like. Remember, you don't have to stick
with green and brown—your frogs can be
any colors and designs you want.

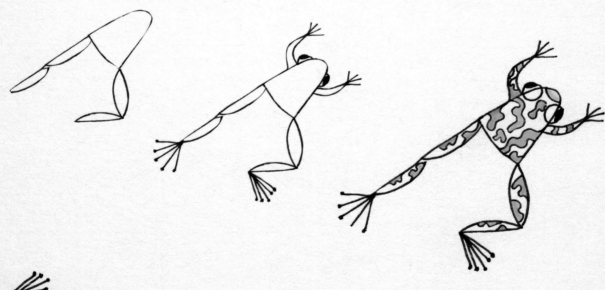

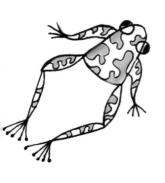
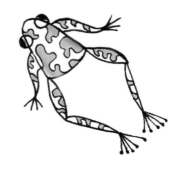
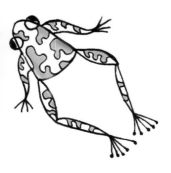
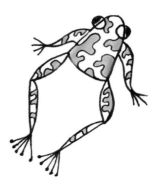

let sleeping dogs lie

Grab a fine-tipped pen
and draw the dog's dream.

Is he chasing rabbits?
Dreaming of a big juicy bone?

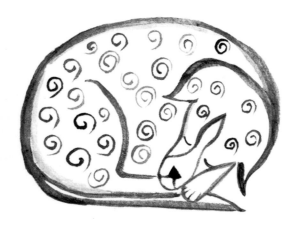

foxes

Practice adding color on these crafty foxes. You can stay traditional with red or brown, or go for more unusual colors.

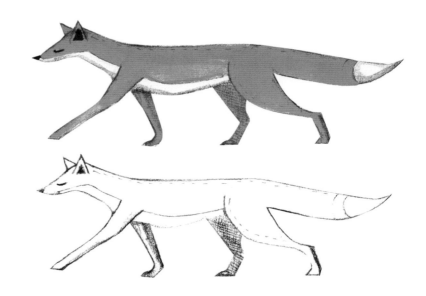

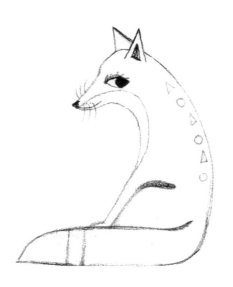

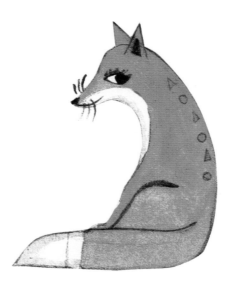

eye music

Synesthesia is that curious phenomenon that mixes
the senses. Some people who are affected can see music.
Some can taste shapes. Others can hear numbers.

Which brings us to the exercise. Your task is to visualize
a song or piece of music of your choice. How might you
convey the various elements of music—such as melody,
harmony, tempo, texture, dynamics, pitch, and timbre—
visually? Through color? Shapes? Pattern?

the face

Have you ever noticed that some people have faces that remind you of a specific shape? Which shape is yours—rectangle, triangle, square, or circle?

Draw yourself using only one type of shape or come up with some other characters of your own.

Rectangle

Triangle

Square

Circle

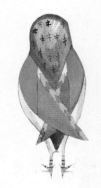

owl

The owl is one of those birds that is guaranteed to bring a smile to your face. This might be something to do with its big eyes and vaguely human appearance, but in some quarters, it's still seen as a bird of ill-omen. I tend to agree with the greeks, for whom it was a symbol of the goddess Athena and wisdom.

gather some pictures of owls from books or the Internet, let go of any preconceived notions of what you think owls should look like and draw some. They can be as detailed or simple as you like, and don't forget those big, round eyes.

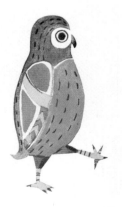

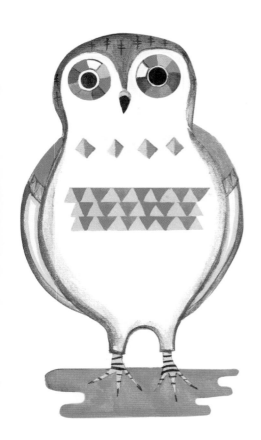

gorilla

Copy a miniature
version of the gorilla
following behind
the adult as they
go through the
jungle together.

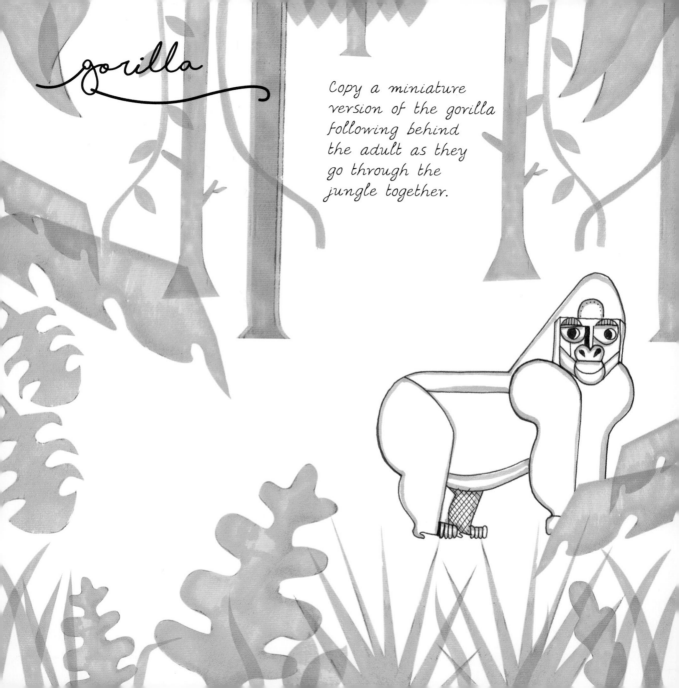

how to shade 3-d fruit

1. Begin with a plain
 base shape.

2. Add shading to one
 side in pastel.

3. gently add black pastel
 to define the edge.

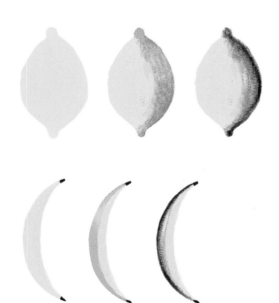

lighthouse

Add a lighthouse to the top of the cliff to keep sailors and their ships from being dashed on the rocks at night.

1. Start with the roof. Draw a triangle, divide it into four.

2. Then move on to the lantern. Draw a rectangle below the roof. Divide it into three smaller rectangles vertically, to create the window panes. Draw a narrow rectangle below the windows to finish off the top of the lighthouse.

3. The striped tower itself is made from two tapered parts, a wider base and a narrower second tier. Draw the classic striped pattern and add a couple of smaller windows too.

4. For the flag, draw two rectangles, the left slightly overlapping the right. Rub out the right-hand end of the one that lies beneath, make it look like a triangle has been cut out of it and you have a pennant.

5. Now add the classic red and white striped pattern, and any extra shading or detailing you want.

6. Finally, to draw the searchlight, shade two horizontal triangles on either side of the lighthouse. Fill them in with lines or dots to further suggest the beams of light.

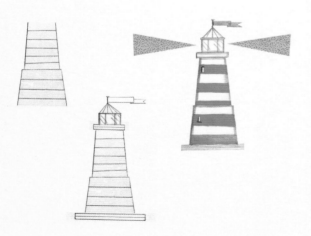

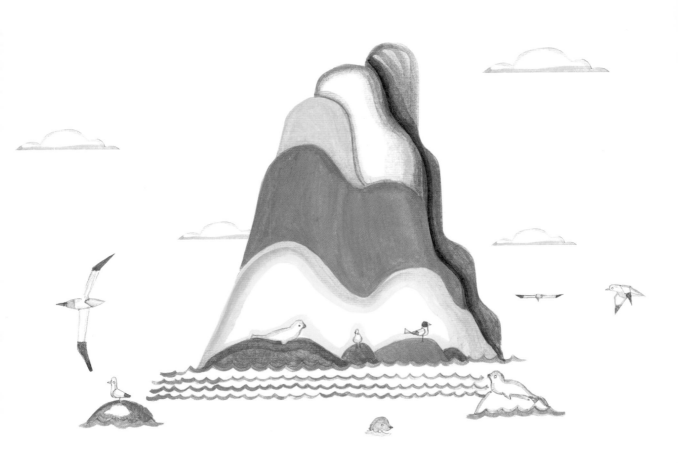

lollipops

All you do is this: first pick a color and draw or paint a big circle. Then select a different shade and paint or draw a smaller circle within the first. And so on, until you end up with seven or eight concentric circles. The stick should be in a neutral black or gray so as not to distract from the lollipop.

And if your circles are a bit imperfect, all the better. That's what makes them individual. Now draw enough lollipops to fill the page and a candy store.

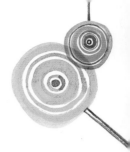

abstraction challenge

From 1905 to 1911, artist Piet Mondrian painted a series of trees, each more abstract than the last. By 1911, he had arrived at pure abstraction.

Let's try it, as I've done with my set of four shoes here. Pick an object and try to reduce it to its essentials. What can be eliminated? Keep this question in mind as you paint or draw a series of images, getting simpler and simpler each time until you can barely recognize the original object. How many different steps and versions of the same object can you make?

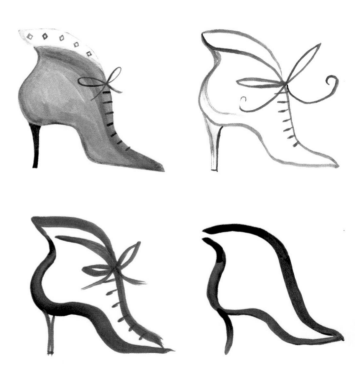

new york skyline

The Big Apple looks
rather unfinished
here. Use a pen to
draw in the myriad
windows and details
to make the city
complete again.

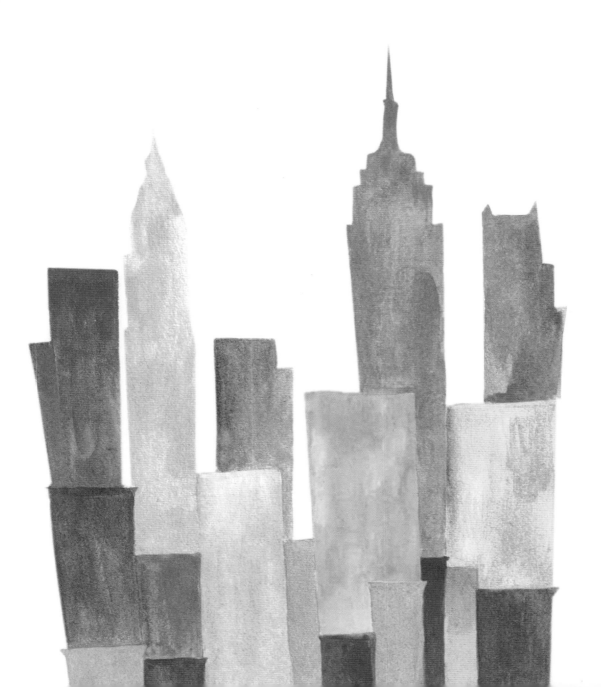

compass points

Here's an unusual exercise in which you are going to look at all four points of the compass and select something to draw within your field of view. In my example, there's a clock to the north, coffeemaker to the east, olive oil jug to the south, and whisk to the west.

Look north and pick an object within, say, a five-foot radius. Draw it in pencil. Repeat the process for south, east, and west. If the objects that you happen to alight on are mundane or everyday, all the better. You should end up with four drawings. Go over them in a fine-tipped pen, and give each a suggestion of color. Think fun and stylized.

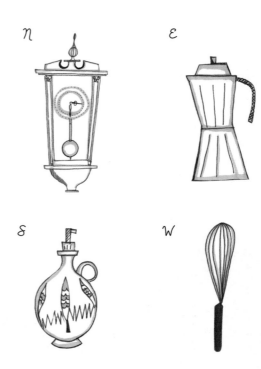

N

E

S

W

piñata

I've drawn my llama with spots, but decorate yours however you like. You can try out a few ideas on the templates here before you draw the final piñata. How big you draw it depends on how generous you are feeling!

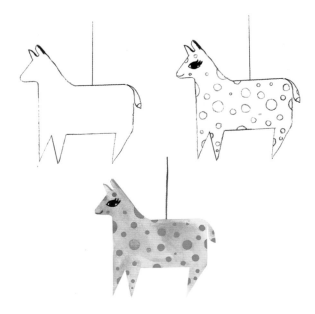

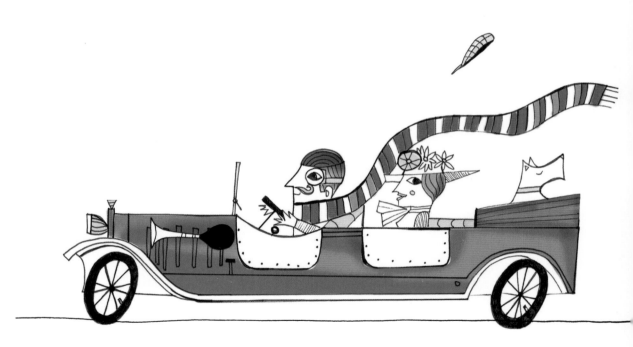

motorcar

This car is speeding down the road. Draw everything in its wake, whether that's dust, leaves on the wind, another car it's racing against, or a surprised pedestrian.

You might also want to add some speed lines or a blurred background for extra effect.

put the hat on the bear

Pick your favorite hat and draw it on the bear's head to complete his look.

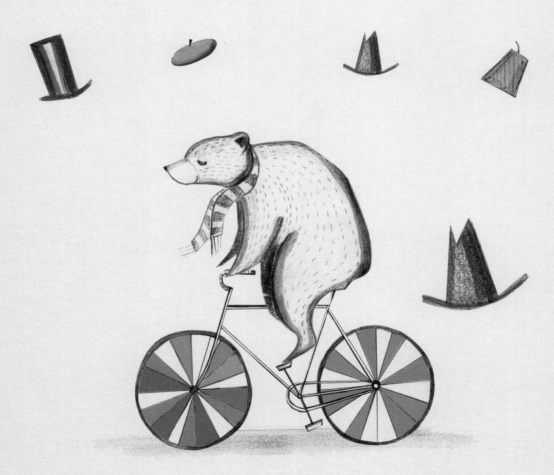

flower arranging

The flowers in this vase are made up of geometrical shapes and patterns. Try copying my example, or if you want, come up with your own arrangement.

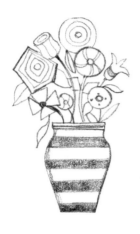

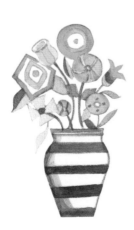

Russian doll

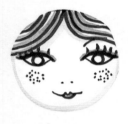

Use this as your model to finish off the doll with touches of pink or purple.

1. First, use a pencil to divide your face into quarters.

2. Then, draw the eyelids. Note how the top and bottom ones curve differently.

3. Add the eyelashes and eyebrows.

4. The nose is two dots on either side of your vertical guideline.

5. Place your mouth beneath the dots: one big and three small curves.

6. For the hair, draw a mountain whose summit lies at the top of the vertical line. Add four smaller lines that follow the curve on each side.

7. Go over everything in ink, add some freckles and wait five minutes so you don't smudge, before erasing your pencil marks.

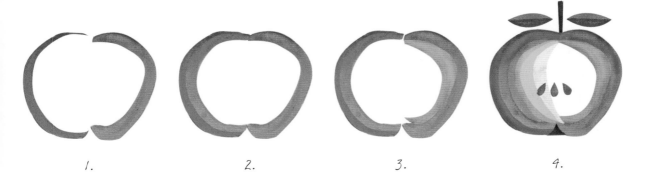

1. 2. 3. 4.

apple

I used paint for this apple, but you can also
try using a thick felt-tip or art pen.

Try some here.

say hello

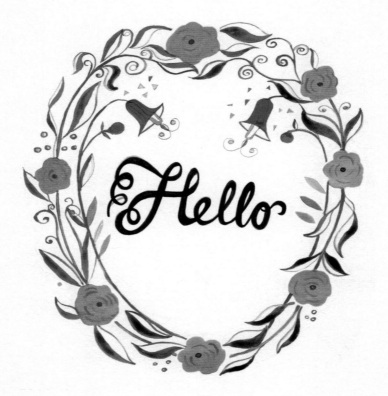

"Ciao," "Salve," "Hola," "Salam," "guten Tag," or just plain old "Hello"—however you want to say it, you can draw it here.

Use your fanciest handwriting, or find some examples of fonts, typefaces, or calligraphy that you can use for inspiration.

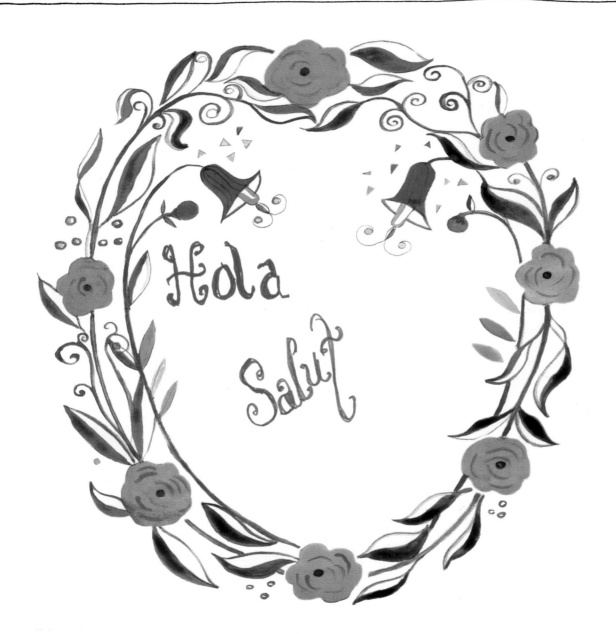

Hello

Now do the opposite. Pick a way of saying "Hello" and design your own border for it. You can make it as weird and wonderful, as ornate or colorful as you like. With drawing there are no limits.

Salve

Ciao

¡Hola!

你好

seal

For this exercise, you are going to draw the sea in which the seal is swimming.

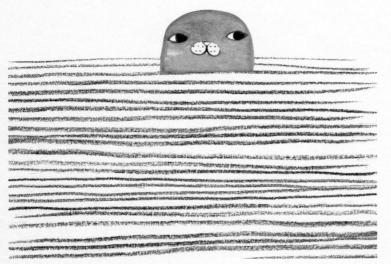

Draw a series of more or less horizontal lines. You can use any media for this that can make nice broad strokes. Don't worry if the lines aren't completely straight, this looks more like natural ripples in the water.

Now add some fish swimming around the seal. This will make the seal much happier, but the fish maybe not so much.

ship in a bottle

Ever wondered how they get those little ships into bottles? You're going to do it the easy way.

Have a little practice first, then draw your final ship. Use pencil for the guidelines and then go over them in felt-tip or pen. Erase the pencil lines and complete your drawing by coloring it in.

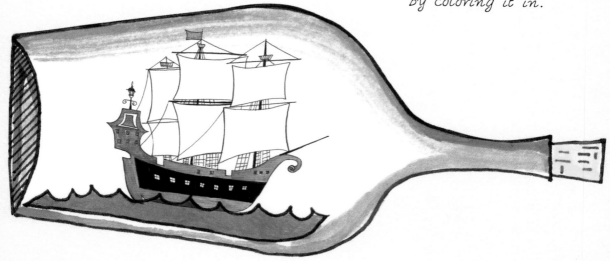

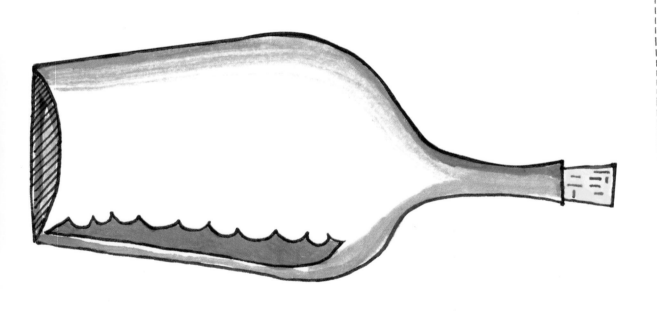

the great snail race

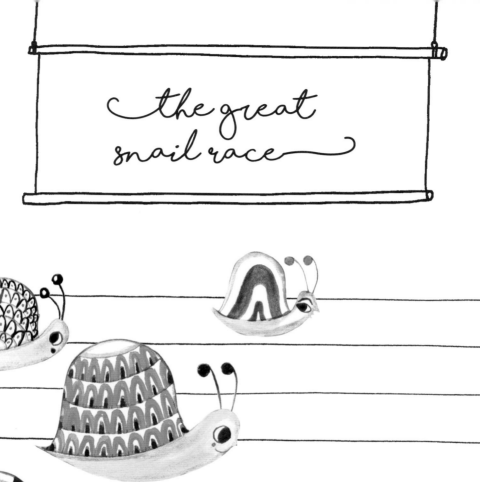

It's the sporting event of the year, and we join the snails mid-race. Perhaps you would care to add to their numbers?

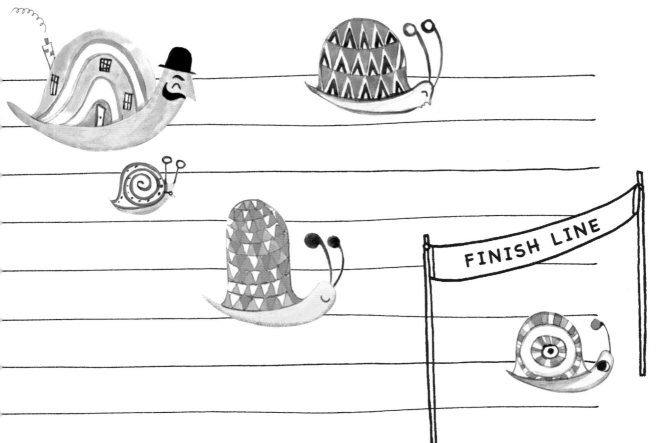

FINISH LINE

sundry cats

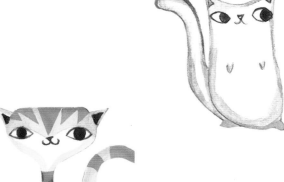
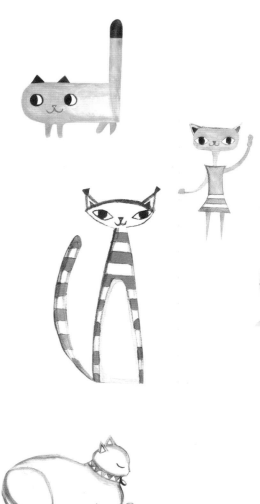

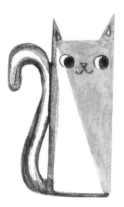

There's nothing like a cat to make
you happy. See how many cat styles
you can draw here.

the march of the teapots

Teapots come in all shapes and sizes.
Draw some here—you could try novelty teapots
or exaggerated, tall, or spindly ones.

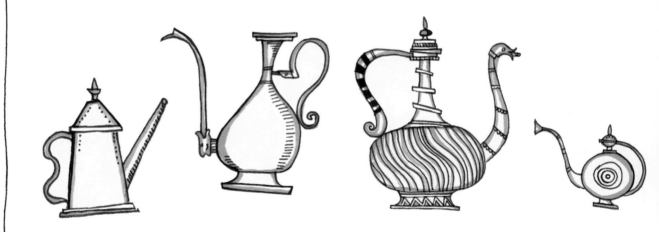

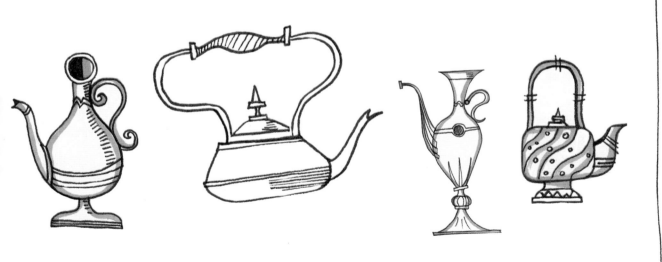

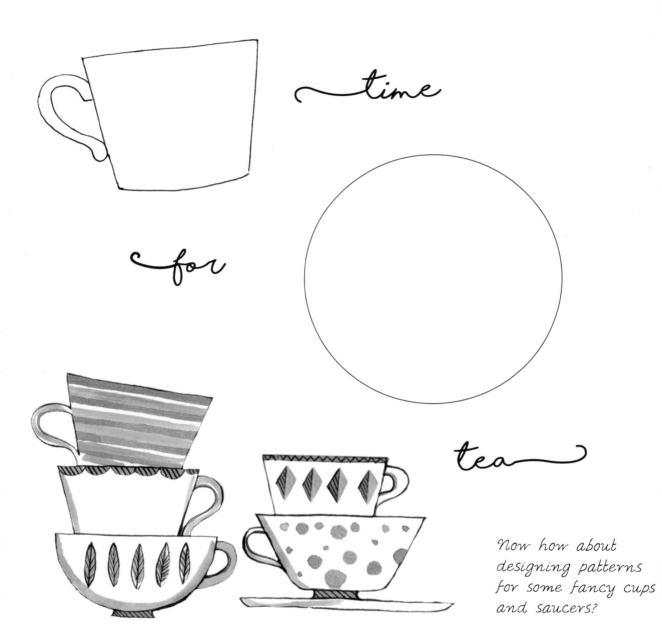

time

for

tea

Now how about
designing patterns
for some fancy cups
and saucers?

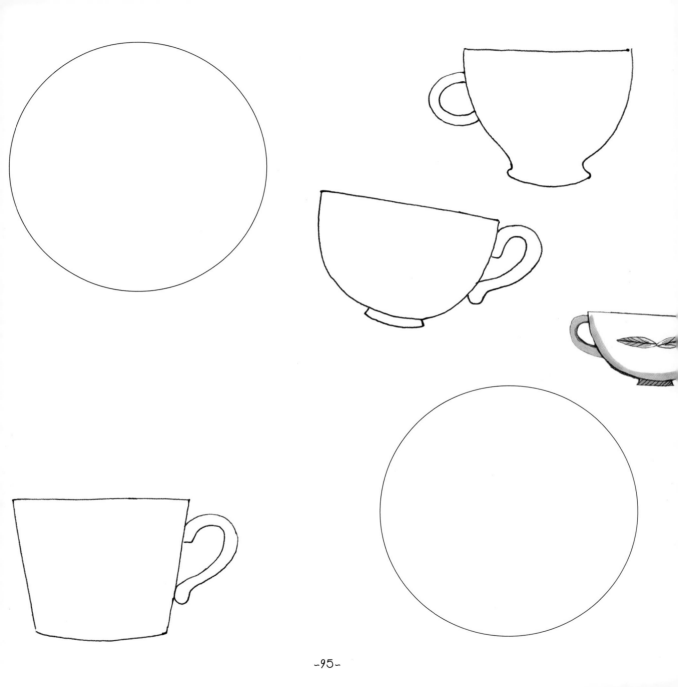

tepees

Traditional North American tepees often featured geometric animal designs. Decorate your tepee with your own contemporary design and add a spiral of woodfire smoke as a finishing touch.

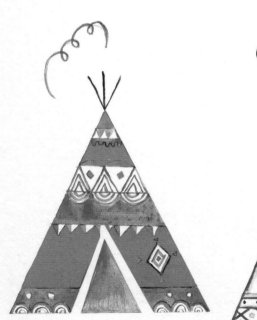

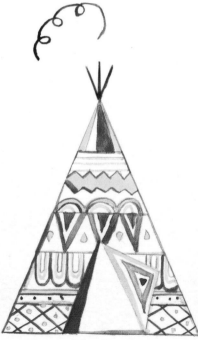

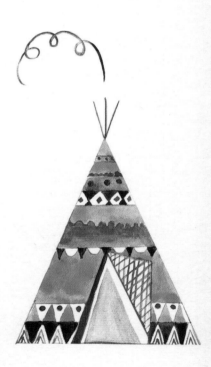

totem pole

Follow up your tepee designs with a coordinating totem pole.

I've given you a template to get you off to a flying start. If you'd rather draw your own, then my advice would be to think of the totem pole as a long rectangle, further divided into smaller rectangles, each representing a totem.

A simple design looks more striking and a dash of bright color is vital for the best effect.

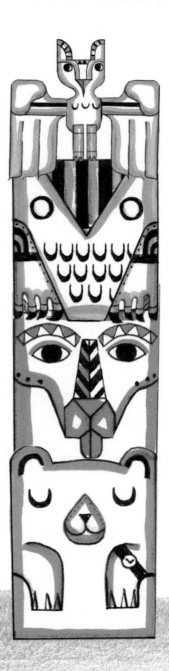

the heavens

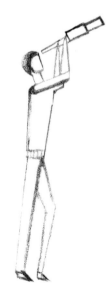

What is this
man looking at?

The stars?
A hot-air balloon?
A spaceship?

Draw in whatever
you think it is.

flower power

Color can lift mood and banish melancholy. Whether you want to draw your favorite flowers or invent some new species of your own, fill the page with warm, vibrant blooms to make you happy.

venn diagrams

Remember these from school? Venn diagrams use circles to represent sets, with the position and overlap of the circles showing the relationships between the sets.

Here are some examples:

- Horse - Unicorn - Narwhal
- Tiger - Liger - Lion
- Bat - Batman - Man
- Tall glasses - Highball - Mixers
- Blue - green - Yellow
- Black bear - Panda - Polar bear
- Candy cane - Zebra - Horse
- Wolf - Werewolf - Man

What examples can you come up with? You can use words of course, or can try drawing icons or small pictures to represent what you mean. The results are often pretty clever!

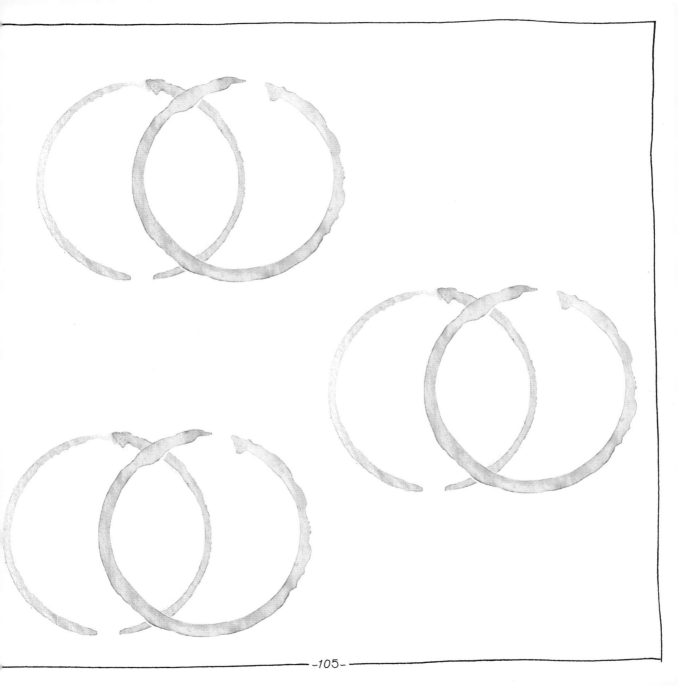

counting sheep

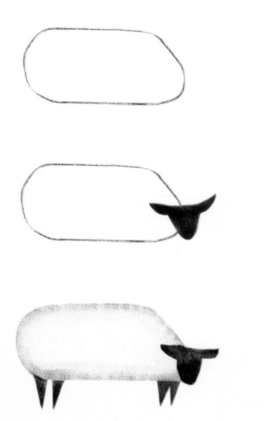

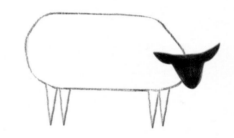

Counting sheep is a good way to get to sleep and drawing them is just as relaxing. Draw as many as you like on this page. You could also add some grass or perhaps make it look like they are dancing or jumping over a fence.

what's on your desk?

Here's what's on mine. You don't need to worry too much about perspective—think of the drawing almost as a mini-map of your desk.

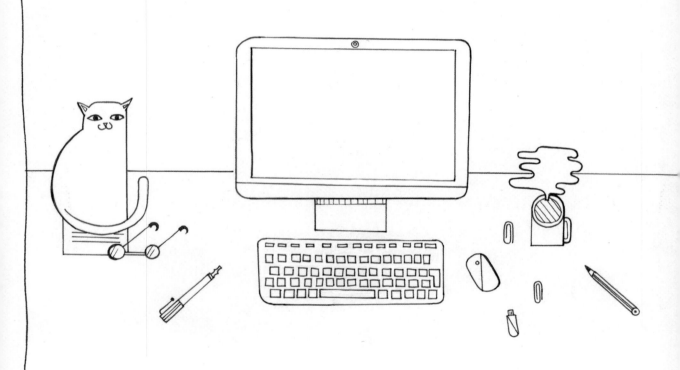

at the beach

This sun-lover appears to have forgotten a number of beach essentials. Perhaps you would kindly add some for her?

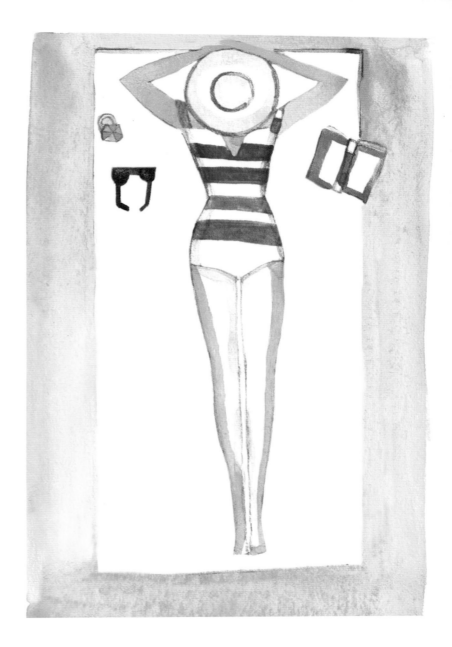

roman holiday

You've probably heard of the headless horseman? Well, here's the headless Vespa motorcyclist. Give her a head —you can copy one of the heads I've drawn or come up with your own.

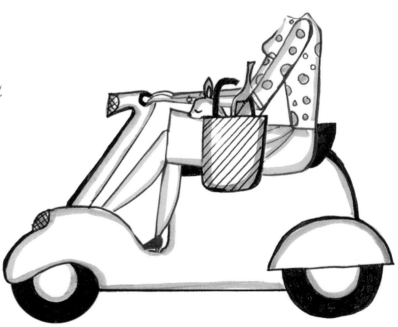

spanish village

Spread some happiness and sunshine in this sleepy village any way you like. Maybe you want to add a radiant sun shining down or a double rainbow in the background? Or maybe some music notes from a party going on!

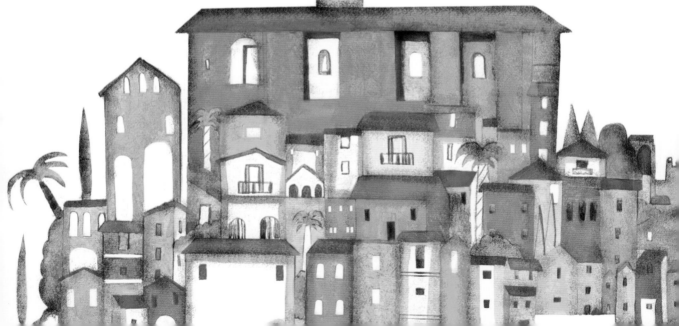

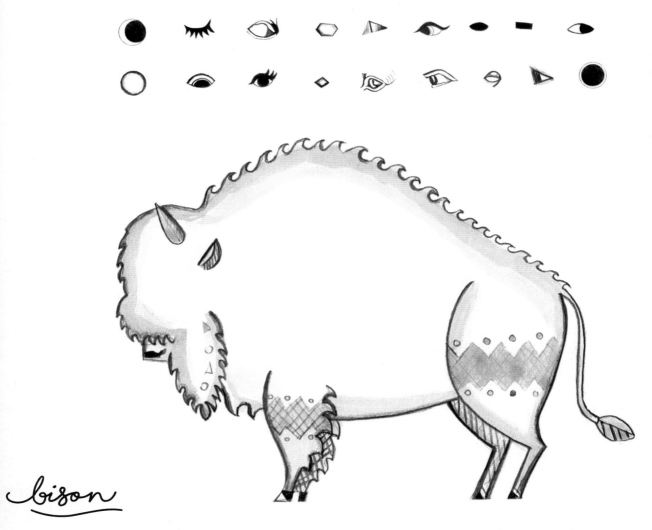

bison

This bison is having a little trouble seeing at the moment.
How many eyes will you draw for it? Just the one peeking out?
Or all over its body, making it some magical all-seeing creature?

gondolier

Complete this Venetian scene by adding the water beneath the boat in broad, sweeping strokes of color. Then use a darker shade for the shadow of the boat and to add some ripples. You could also use the same method for the sky and then draw in a bridge or some buildings too.

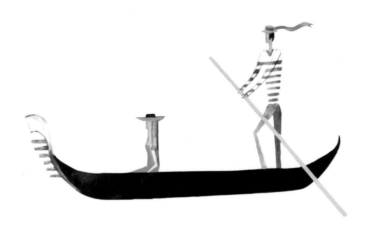

fisherman

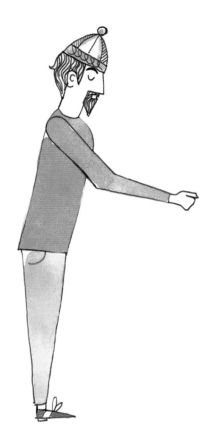

This fisherman will only get a bite if you lend a hand. First, draw him a fishing rod with a hook, and then add more fish in the water to increase his chances of catching something. You can also add more flowers along the riverbank to brighten up the scene further.

gelato

If there's one thing guaranteed
to make you happy, it's ice cream.
Whether it's strawberry, chocolate,
pistachio, or bubblegum, draw
your favorite flavors then add
the toppings—sprinkles, nuts,
hot fudge . . .

st. bernard

St. Bernards are excellent rescue dogs, carrying items around their necks to travelers lost in the snow. What would this St. Bernard bring to rescue you? The traditional barrel of brandy or something else? Draw your choice hanging around the dog's neck.

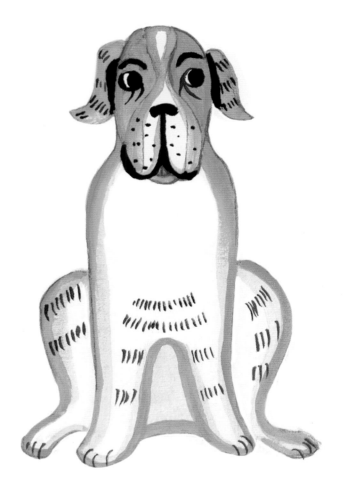

drummer

Add some more drums to this drummer's set to really make some noise! Then color it in, maybe adding in a band name or logo to personalize it.

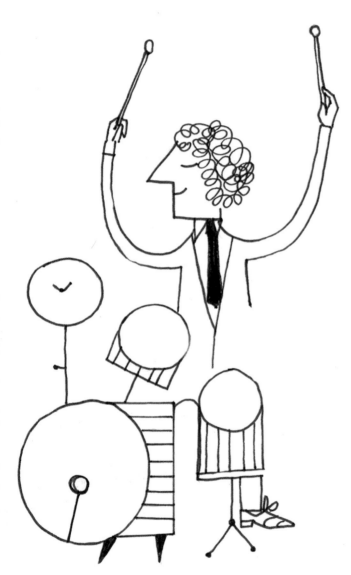

bridge

There's a building missing from this bridge and your job is to plug the gap.

Here's how:

2.

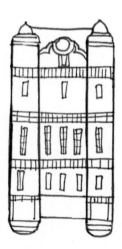

3.

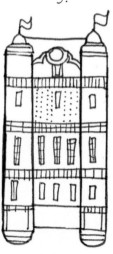

4.

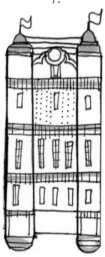

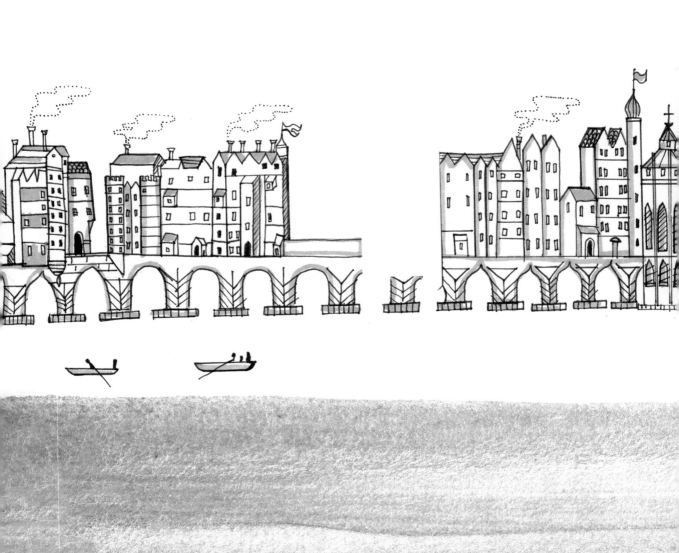

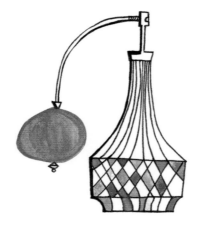

become a perfumer

What are your favorite scents? Roses? Coconuts? Just-mown grass or freshly washed clothes? It doesn't matter if they don't really go together, draw or write these things coming out of the bottle to make your ultimate imaginary perfume.

Next, try designing your own perfume bottle.
I've given some examples to start you off. Think about
how the bottle will represent what's inside and the
name of your perfume, if you've given it one.

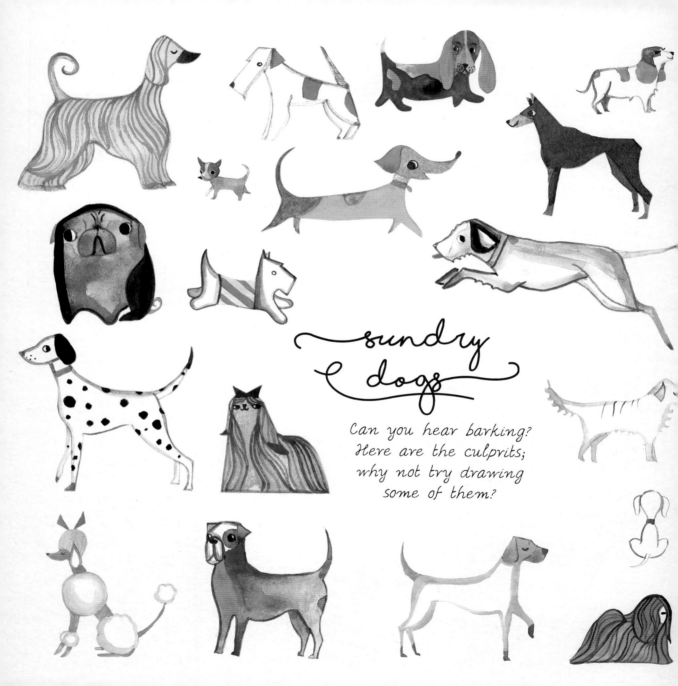

sundry
dogs

Can you hear barking?
Here are the culprits;
why not try drawing
some of them?

city walls

This mighty city wall is built from a selection of simple geometrical shapes— circles, triangles, squares, rectangles, and variations in between—shaded in. First, decide what shapes you want to use, then set about continuing the wall. Think about how high and wide you want to make it. It could include towers and maybe a gate or drawbridge too.

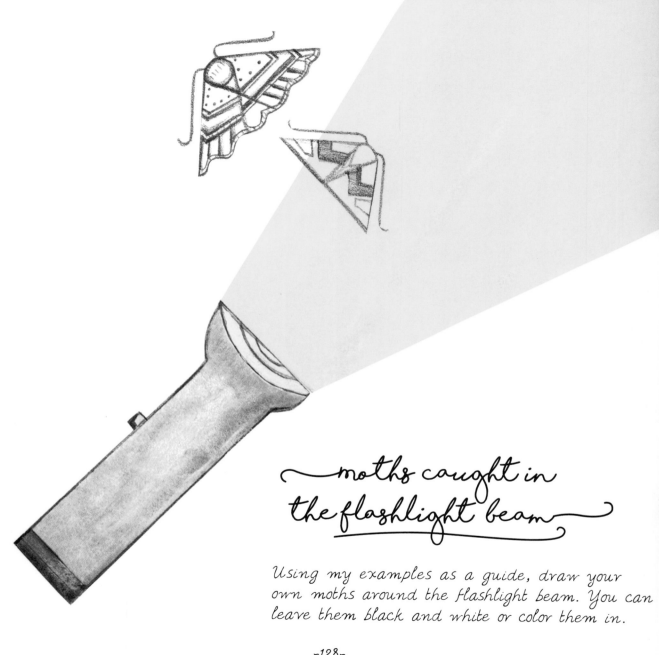

moths caught in the flashlight beam

Using my examples as a guide, draw your own moths around the flashlight beam. You can leave them black and white or color them in.

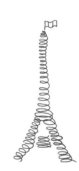

What is happiness?
A café au lait on a sunny
Paris morning must rank pretty
high up on the list. Simply add
some detail to the outline of
the Eiffel Tower as I have done
above, to complete this relaxing
Parisian scene.

ice cream sundae

Ice cream is better when eaten with friends. Turn this girl's plain sundae into a colorful delight. Then draw her some friends and give them each a dessert too. Don't forget the cherry on top for each one!

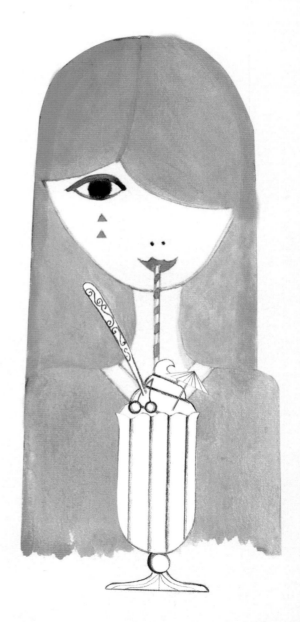

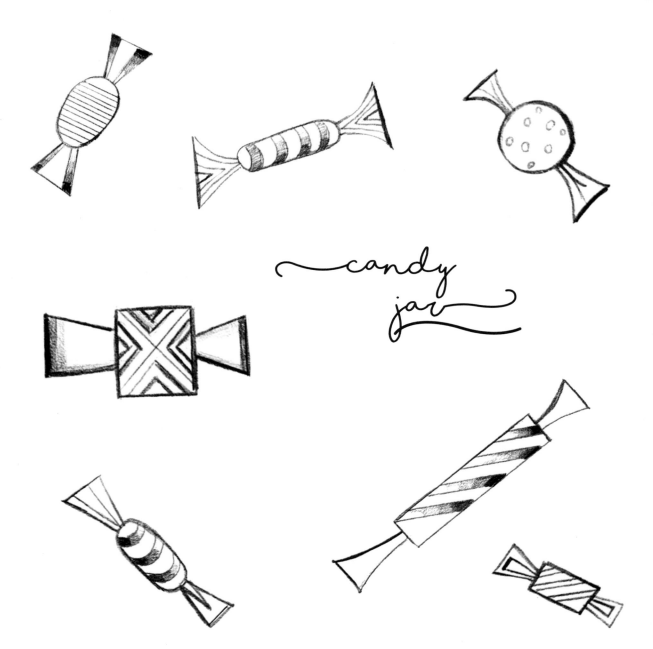

candy jar

Now it's your turn
to draw some candy.
Fill the jar with
them, ready for it
to be raided!

accessories

No outfit is complete without accessories, so give this thoroughly fashionable gal some earrings and the perfect necklace.

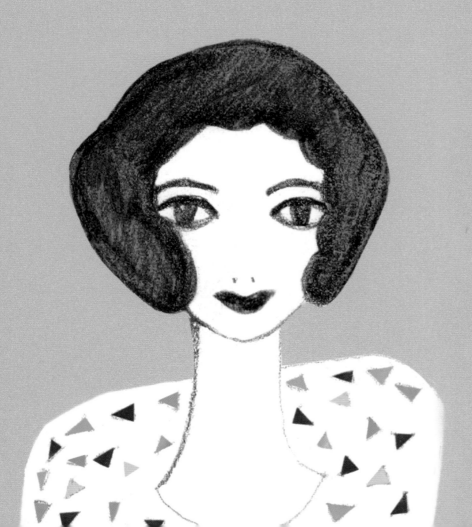

kite

This man has lost his kite!
Draw one in for him as he
chases after it.

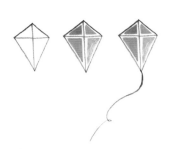

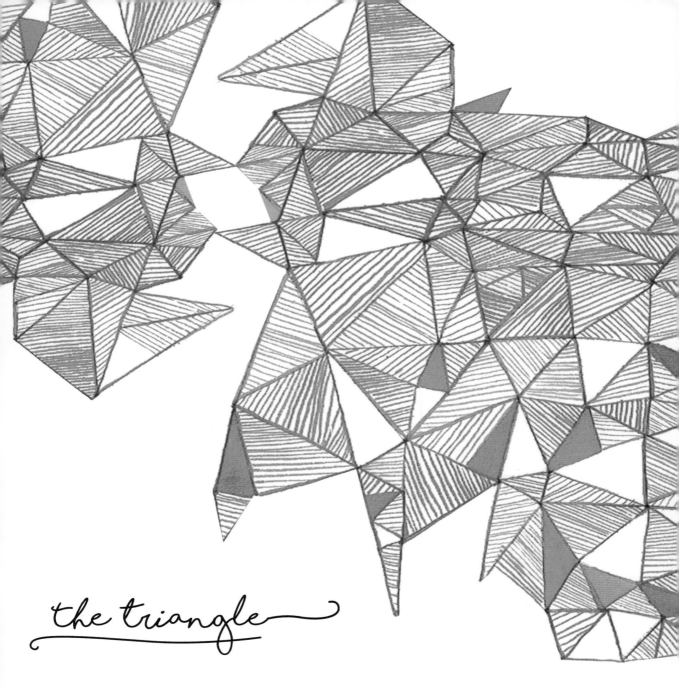

the triangle

Here the humble triangle is used to create a pattern. All you have to do is draw a triangle, add some hatching on the diagonal, then draw another that has at least one tip touching the first. For contrast, make some triangles solid red and leave some blank. The blank triangles will reveal themselves from negative space —I've started you off here.

a walk in the park

What you see here is the result of an afternoon in a park in Basel, Switzerland. I gathered some pine cones and made sketches of what I saw.

Take a walk outside and have a look around you. Try to simplify or stylize the interesting things you see and record them here. Leaves, trees, animals, people—anything can be turned into a sketch or a pattern.

strongman

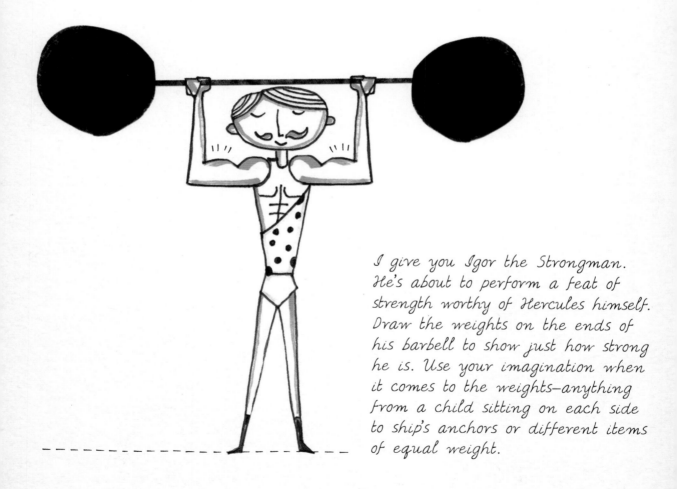

I give you Igor the Strongman. He's about to perform a feat of strength worthy of Hercules himself. Draw the weights on the ends of his barbell to show just how strong he is. Use your imagination when it comes to the weights—anything from a child sitting on each side to ship's anchors or different items of equal weight.

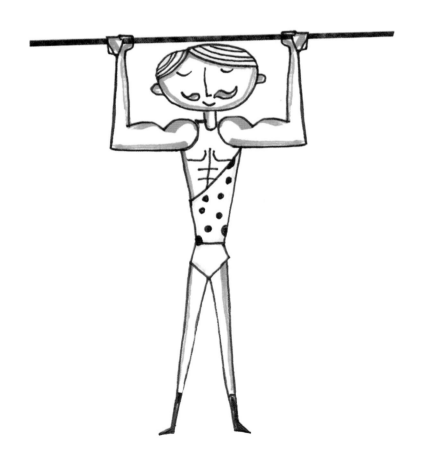

book
towers

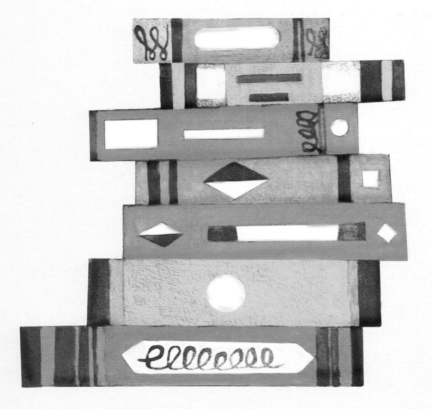

Draw as many piles
of books as you like,
balanced as high
as you like, and
add in the titles
if you want to too.

peacocks

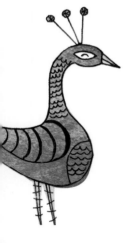

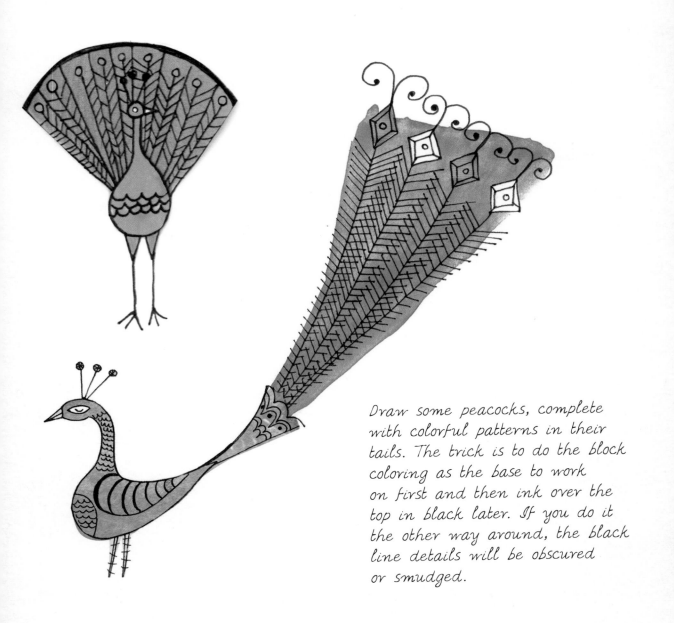

Draw some peacocks, complete
with colorful patterns in their
tails. The trick is to do the block
coloring as the base to work
on first and then ink over the
top in black later. If you do it
the other way around, the black
line details will be obscured
or smudged.

rainbow snake

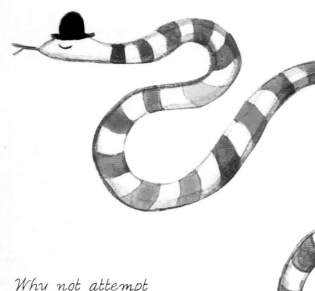

Why not attempt
this sinuously sibilant
snake? Draw your snake
twisting and turning
across the page.

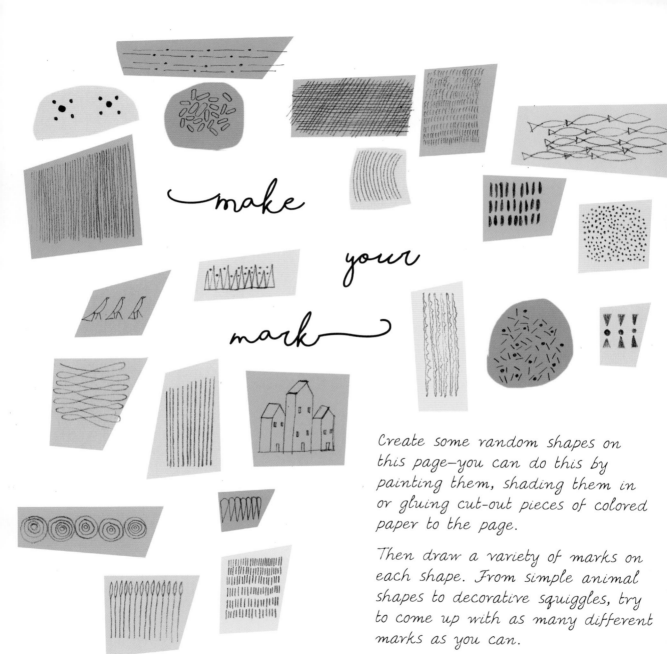

make your mark

Create some random shapes on this page—you can do this by painting them, shading them in or gluing cut-out pieces of colored paper to the page.

Then draw a variety of marks on each shape. From simple animal shapes to decorative squiggles, try to come up with as many different marks as you can.

terrarium

You're going to create a terrarium filled with whatever you want. From cacti and houses to animals and tiny people, your choice of subject matter is endless. Think impossible, ridiculous, incongruous and use any media that feel right.

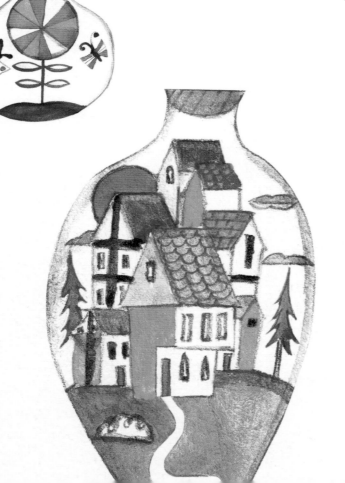

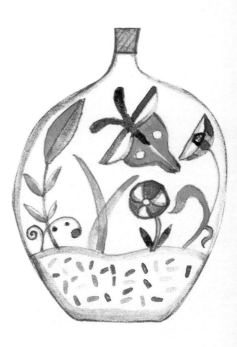

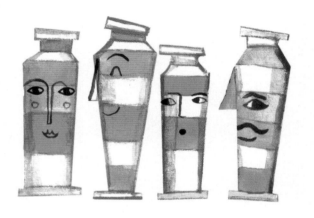

tools of the trade

If there is a secret to drawing yourself happy, it's this: anthropomorphize— humanize inanimate objects. Things are more fun when you make them look fun. So with this in mind, gather whatever art materials you have at hand and bring them to life by giving them faces and personalities.

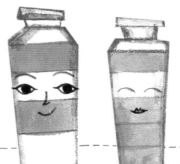

hats off
to that

13^th C

16^th C

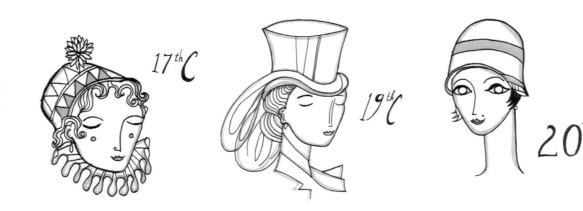

17thC 19thC 20thC

What style of headgear appeals to you the most? Try drawing some of these, or come up with your own vintage hats and perhaps even imagine some from the future.

a fat-free feast

Indulge in this selection of delicious and beautiful treats—being drawings, they are completely fat free, sugar free, and guilt free so draw as many as you want!

The idea here is to use solid block colors and shapes to give a clean-cut effect; use my examples as a guide.

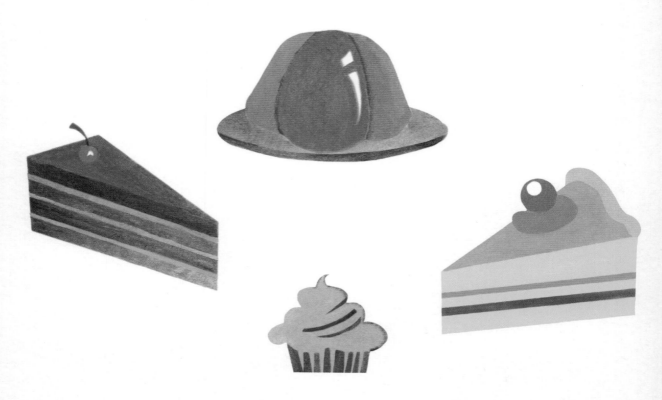

coat of arms

The language of heraldry is a curious one, involving things like gules, blazons, tinctures, charges, and bends sinister. Devise four symbols that sum you up and add a motto too.

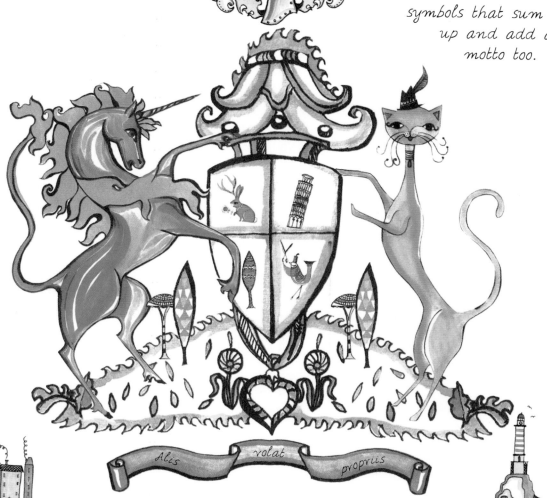

Alis volat propriis

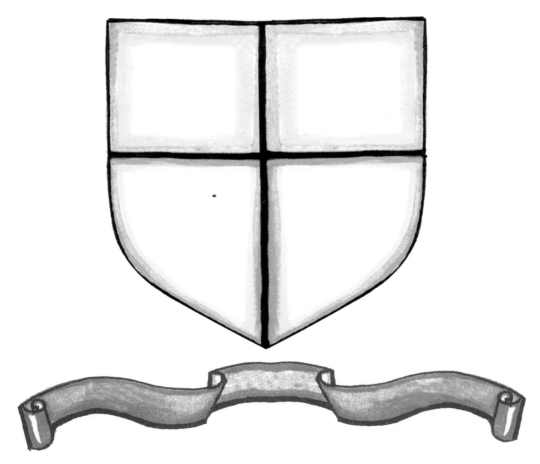

patchwork tree

give the bare tree opposite
some much-needed coverage
with a patchwork blanket,
by joining together straight-
edged geometrical shapes,
until its branches are
completely covered.

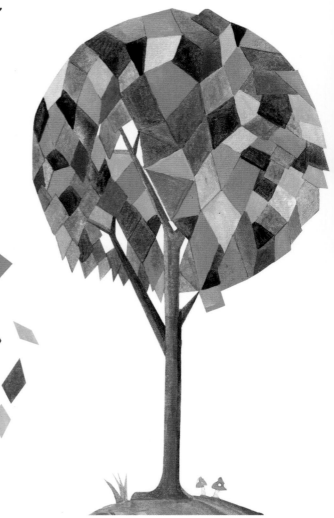

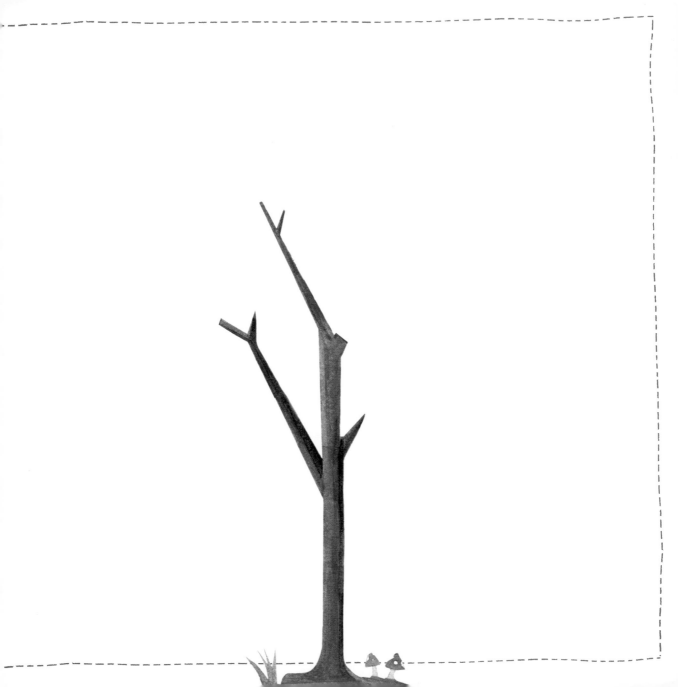

flying fish

Draw the rolling waves of the sea
and more fish flying through the air
above it in formation. Don't forget to
add lots of color!

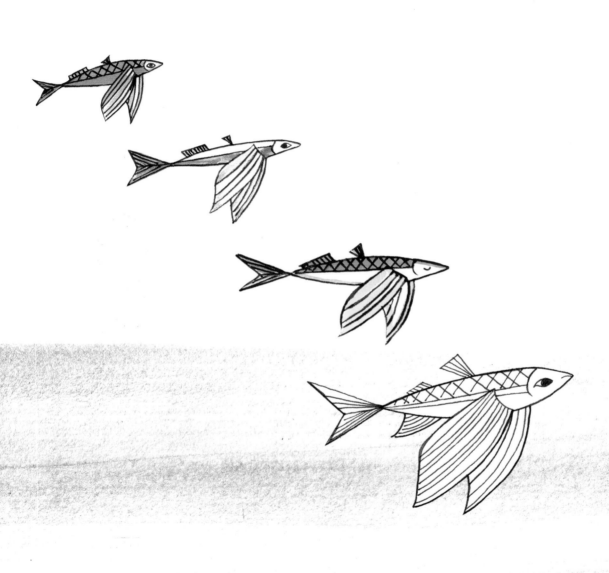

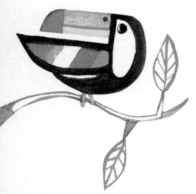

toucans

Using my outline and examples as
a guide, draw your own toucans here.
Think about what other details you
can add, like branches, leaves, and
jazzy patterns.

a victorian menagerie

Here and over the page you see some fine Victorian ladies and gentlemen minus their heads. With a touch of the comic and surreal, perhaps you could remedy the situation by giving them animal heads instead, like I have.

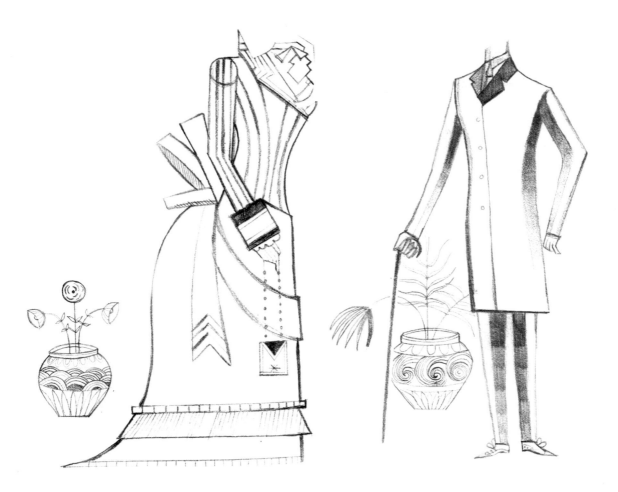

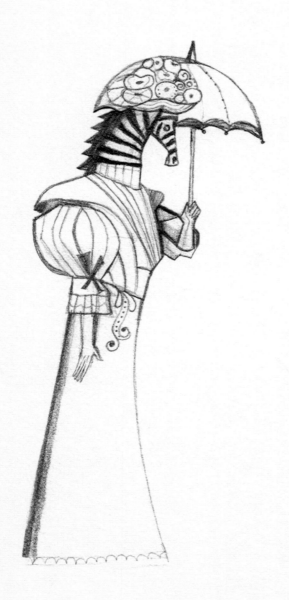
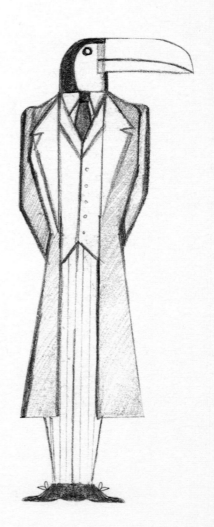

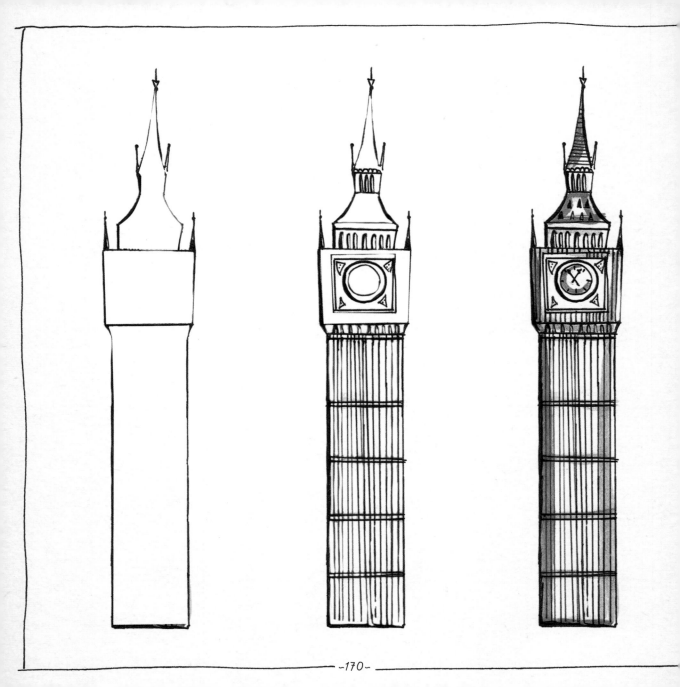

big ben

Try drawing your own version
of Big Ben. I've shown the
main steps here for you to
follow—remember, this is not a
technical drawing, so if your
lines are a bit crooked, all the
better to give it some style.

create a monster

Rev up your imagination and see
what strange and hideous forms
you can call forth from the dark
corners of your mind to draw here.

monster band

What is a band without an audience to play for? Draw in the screaming crowd in front of the stage and the set behind it. Does it have the band's name in flashing lights? Flamethrowers and dry ice?

what news?

Draw the headlines of the day on this newspaper.

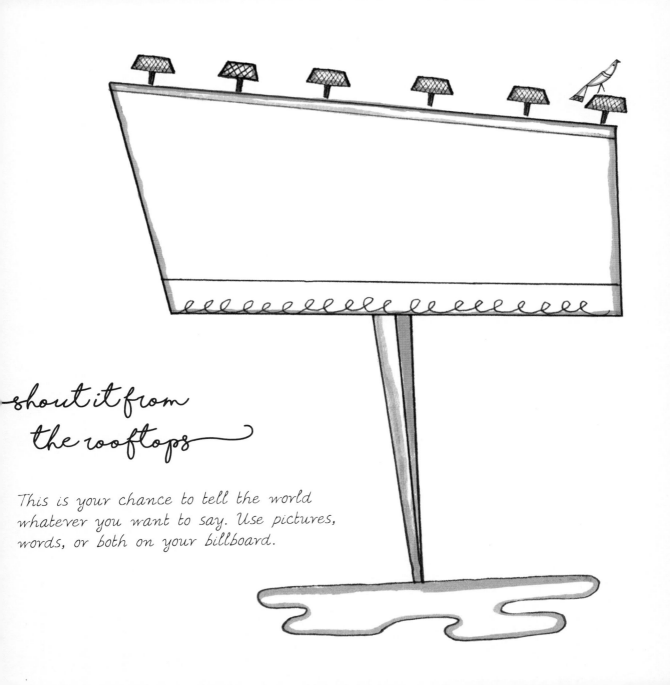

shout it from
the rooftops

This is your chance to tell the world
whatever you want to say. Use pictures,
words, or both on your billboard.

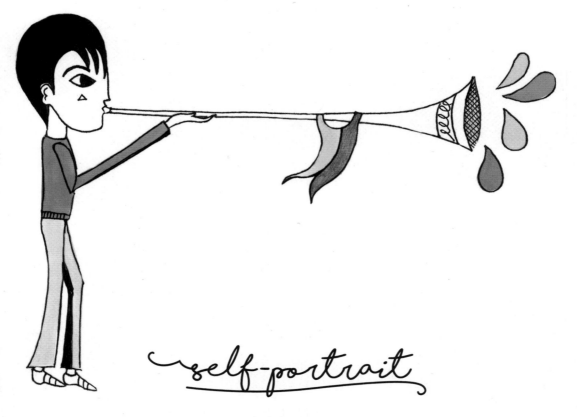

self-portrait

What makes you . . . you? Draw a self-portrait that represents your personality or the things you like. It can be as simple or as detailed as you want, as long as it makes you happy!

(This is me, by the way, to give you an idea.)

the ballerina

Turn this girl into a prima ballerina by giving her a tiara and a costume. Use a colorful, bold design to make her stand out.

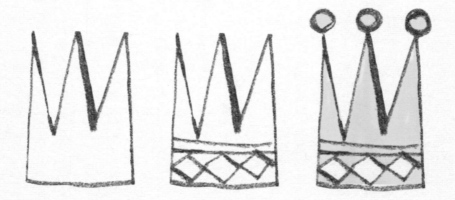

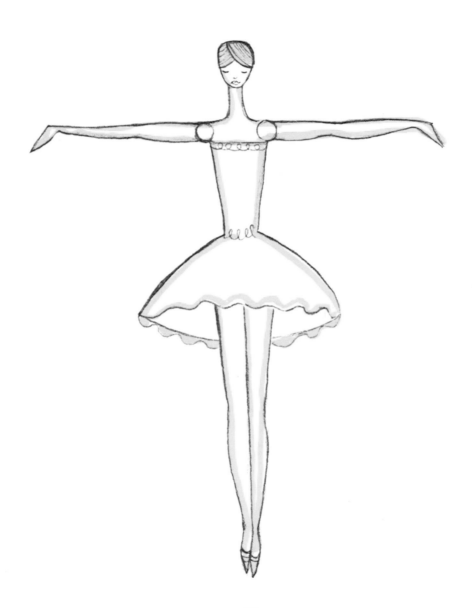

draw a panda in four easy steps

Mastering cute panda faces is easy. All you need is a pencil (perfect for making a smudgy outline) and a black marker pen.

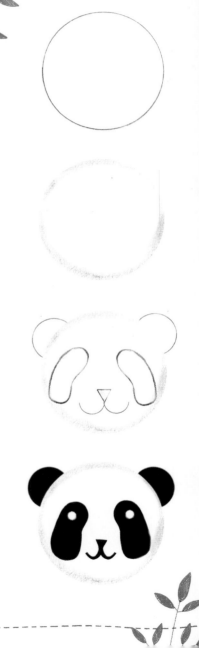

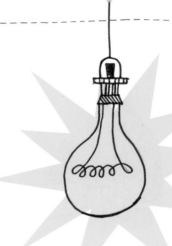

light bulb moment

Fill the page with light bulbs in pen and add some fluorescent neon color for each one to light up the page.

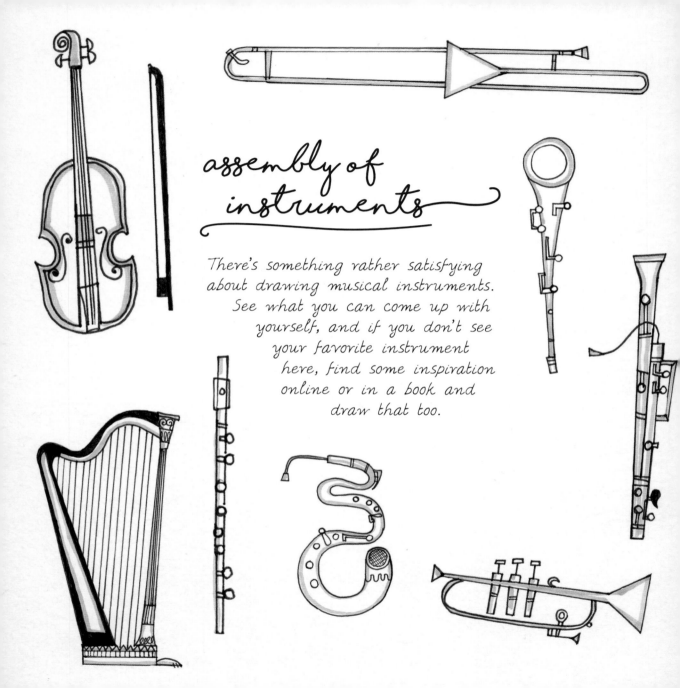

assembly of instruments

There's something rather satisfying about drawing musical instruments. See what you can come up with yourself, and if you don't see your favorite instrument here, find some inspiration online or in a book and draw that too.

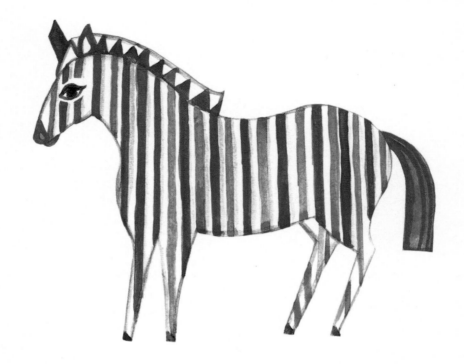

horse

I've layered stripes of red, blue, and green on top
of each other to create my zebra with a ripple effect,
but you can make your horse your own in any way
you like—maybe giving it wings, making it a unicorn,
or giving it a patchwork pattern.

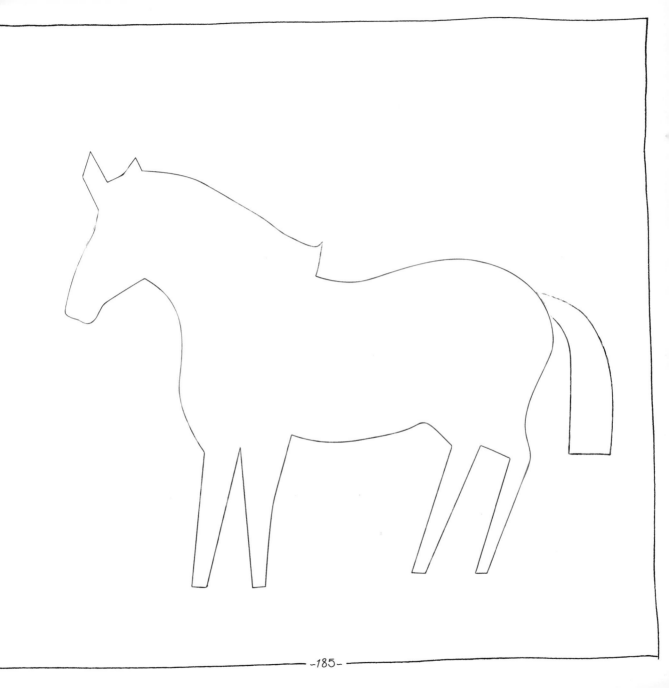

sleeping kittens

What could be more serene than sleeping kittens? Essentially made up of a bean shape and pointy ears, they're so simple to draw too. Fill the page with more kittens all having an afternoon nap together.

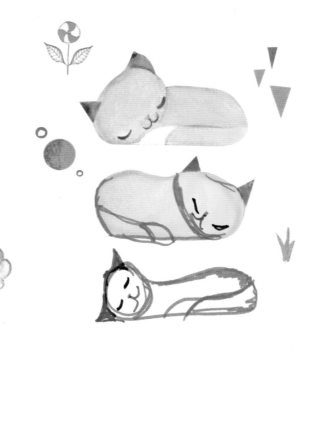